AN OPINIONATED GUIDE

Women
Painters

HOXTON MINI PRESS

Contents

Hildegard of Bingen *18*

Sofonisba Anguissola *20*

Lavinia Fontana *22*

Artemisia Gentileschi *24*

Michaelina Wautier *26*

Rachel Ruysch *28*

Angelica Kauffman *30*

Élisabeth Louise Vigée
 Le Brun *32*

Sarah Biffin *34*

Amalia Lindegren *36*

Berthe Morisot *38*

Mary Cassatt *40*

Harriet Backer *42*

Julia Beck *44*

Anna Bilińska *46*

Cecilia Beaux *48*

Anna Mary Robertson Moses
 (Grandma Moses) *50*

Hilma af Klint *52*

Suzanne Valadon *54*

Aurélia de Souza *56*

Mabel Pryde *58*

Emily Carr *60*

Uemura Shōen *62*

Gwen John *64*

Laura Knight *66*

Vanessa Bell *68*

Madeline Green *70*

Zinaida Serebriakova *72*

Sonia Delaunay *74*

Georgia O'Keeffe *76*

Marlow Moss *78*

Nina Hamnett *80*

Dod Procter *82*

Tamara de Lempicka *84*

Lotte Laserstein *86*

Alice Neel *88*

Evelyn Dunbar 90

Frida Kahlo 92

Lee Krasner 94

Emily Kame Kngwarreye 96

Amrita Sher-Gil 98

Maria Lassnig 100

Luchita Hurtado 102

Françoise Gilot 104

Joan Mitchell 106

Helen Frankenthaler 108

Eva Frankfurther 110

Bridget Riley 112

Paula Rego 114

Mary Heilmann 116

Pat Steir 118

Maggi Hambling 120

Lubaina Himid 122

Beatriz Milhazes 124

Tracey Emin 126

Nicole Eisenman 128

Cecily Brown 130

Shahzia Sikander 132

Chantal Joffe 134

Julie Mehretu 136

Amy Sherald 138

Chen Ke 140

Thenjiwe Niki Nkosi 142

Njideka Akunyili Crosby 144

Hulda Guzmán 146

Flora Yukhnovich 148

Why care about women painters?

The museums of the world teem with women: beautiful ones, viperous ones, young and old (well, mostly young), seated and recumbent. But, until very recently, they were almost always in the frame rather than on the labels.

Yet women have always painted, despite the discouragement lobbed in their path. Laws, religion, restricted education, academic snobbery, public disapproval, having to get their husbands' supper on the table, museums not buying their work, historians refusing to acknowledge their work, fellow artists referring to their kind as 'ridiculous' (Renoir) – none of it has prevented women from sitting at an easel, picking up a brush and doing it anyway.

Often it was precisely these constrictions that led women to go off in an original direction. To carve out time, find money and a room of their own – or at least a corner of one. To summon courage to be disruptive when mere acceptance and recognition were hard enough to come by. To retain their sanity around men who said things like 'Let's not have any of those damned women' – as English artist CRW Nevinson remarked to the painter and critic Wyndham Lewis when forming the (short-lived) Rebel Art Centre in 1914.

Let's be clear though: this book isn't about recuperating women painters, nor does it consider them curios. We don't see Rachel Ruysch (p.28) or Mary Cassatt (p.40) as prodigy artists: we want to look at them as painters on their own terms, as thinkers and creators. Their work – all of these women's work – is enlightening, transformative. We can't fully understand the history of art without them.

A short

history

Within convent walls, many medieval women found the latitude to cultivate a creative gift. They worked in manuscript illuminations, but identifying their work is a challenge – most of it's unsigned. Women painters begin appearing in records in the Renaissance, all of them trained and stewarded by a male relative, since they were prohibited from apprenticeships, academies and guilds, and from representing themselves in business.

Private clubs and Salons, along with formalised Academic training, shaped the 18th-century art world, and women were barred from the lot, though it didn't take long for someone to perceive an opportunity for financial gain. Masses of private academies sprung up and by the late 19th century, the art establishment was losing its grip and groups like the Impressionists welcomed women into their fold.

By the time Gwen John (p.64) enrolled at the Slade School in the mid-1890s, two-thirds of the students were women, even if they had to paint in long skirts and hats. Enter the corsetless, short-haired 'New Women' artists of the 1910s and 20s, followed by mid-century mavericks including Sonia Delaunay (p.74) and Bridget Riley (p.112), who were crucial in advancing abstract European art – as were women Abstract Expressionists in America. Both Second Wave Feminism in the 1970s and the Black British Art movement of the 1980s made huge strides in challenging convention and tackling women's visibility. Their legacy means that today, women painters reshape the narrative at will.

A brief timeline

Painting in obscurity *dawn of time to 1500s*
'Anonymous was a woman.' Virginia Woolf's quotation feels apt for this period, when women painted behind closed doors and without recognition – the word 'anon' plagues medieval art more generally. We do know, however, that some aristocratic and holy women received training in painting, the latter often involved in manuscript illumination.

Women enter the record *mid-1500s*
Sofonisba Anguissola (p.20) is internationally recognised for her portraiture, arriving in Madrid to serve as court painter to Elisabeth of Valois, wife of Philip II of Spain; the Flemish miniaturist Levina Teerlinc becomes court painter to the Tudor court. In Antwerp, Catharina van Hemessen makes the earliest surviving self-portrait of an artist sat at an easel.

Women become official *1630s*
Judith Leyster and Sara van Baalbergen are admitted to a Guild of Saint Luke in the Netherlands, meaning they can sell work, establish a workshop and take apprentices.

Cracking the Academies *1660s–1770s*
Baroque painter Artemisia Gentileschi (p.24) is the first woman to become a member of Florence's Accademia delle Arti del Disegno; Angelica Kauffman (p.30) and Mary Moser become founder members of the Royal Academy.

Women begin to mobilise *1850s–early 1900s*
The Society of Female Artists is established in London, The Woman's Art Club in New York and the Union of Women Painters and Sculptors in Paris. May Morris forms the first women's guild – as an alternative to the men-only Artworker's Guild founded by her father, William.

Schools inch open their doors *late 19th century*
After Laura Herford is accidentally admitted to the Royal Academy Schools (her drawings were submitted with just her initials) and a petition appears in the *Athenaeum* magazine, 34 more women join the ranks. In Paris, where women are excluded from the state-sponsored École des Beaux-Arts, a flurry of expensive private ateliers and schools invite applications from women, who come in droves from all over Europe, Scandinavia and America.

Women petition for equality *1870s*
French artist Jean-Auguste-Dominique Ingres opens his studio to women apprentices, but will only let them paint flowers, fruits, portraits and genre scenes. Meanwhile, most schools remain segregated and forbid women to paint from the nude. In 1871, the Slade becomes the first art school to allow its female students to study from the male nude, so long as the model wears a modesty pouch.

Things get (a bit) more inclusive *1870s*
Berthe Morisot (p.38) and Mary Cassatt (p.40) are invited to exhibit with the Impressionist group, lauded by their peers and critics alike, though – since society frowns on the idea

of a woman keeping a studio or going anywhere to paint unchaperoned – their work is by necessity mostly done at home. Morisot responds by setting up a weekly salon in her apartment.

At the helm of new movements *early 1900s*
In Stockholm, Hilma af Klint (p.52) produces the first abstract painting (predating Abstraction's so-called pioneers Vasily Kandinsky, Kazimir Malevich and Piet Mondrian by a good few years). In London, inspired by Post-Impressionist painters, Vanessa Bell (p.68) begins to prioritise form and colour over subject matter.

Women carve out the New York art scene *1929-1939*
Four iconic museums (MoMA, the Whitney, the Frick and the Guggenheim) emerge during this decade, all with women founders. Meanwhile, Peggy Guggenheim, Grace Nail Johnson and Florine Stettheimer establish influential galleries and salons aimed at fostering avant-garde art.

Women join the ranks *1930s and 1940s*
Laura Knight (p.66) becomes the first woman elected to full membership of the Royal Academy and, along with Evelyn Dunbar (p.90), one of a handful of women to be commissioned as an official war artist during World War II.

Women take a seat at the table *1967*
Laura Knight was an Academician for 30 years before she was invited to the traditional annual dinner – thanks to the wood engraver and sculptor Gertrude Hermes, who

campaigned to overturn the archaic 200-year-old rule of male-only dining (and who, *The Times* reported, enjoyed 'a thoroughly masculine cigar' at the table to celebrate).

Women contend their place in history *1970s*
Linda Nochlin publishes her now famous 1971 essay, 'Why Have There Been No Great Women Artists?'– arguing that the real issue is not the lack of them, but the systematic barriers to education, patronage and exhibition opportunities that had rendered them historically invisible and few in number. Elizabeth Broun and Ann Gabhart coin the term 'Old Mistresses' to expose the gendered language of art history, and Rozsika Parker and Griselda Pollock begin to track writings on women artists, proving that prior to the early 20th century, literature was filled with women artists.

Women of colour are increasingly represented *1980s*
Lubaina Himid (p.122) organises a series of groundbreaking exhibitions presenting the work of Black and Asian women artists, including *Five Black Women*, *Black Woman Time Now* and *The Thin Black Line*.

Prize-winning women *1990s–2010s*
In 1993, Rachel Whiteread is the first woman to win the Turner Prize; Lubaina Himid becomes the first Black woman to win in 2016. The same year, Amy Sherald (p.138) becomes the first woman to win the Smithsonian National Portrait Gallery's portrait prize, and is subsequently chosen by Michelle Obama to paint the former First Lady's official portrait.

All change at the top *2010s*

The Royal Academy appoints its first female Keeper (Eileen Cooper), its first female professors – Tracey Emin (p.126) and Fiona Rae – and its first female President (Rebecca Salter). Zelfira Tregulova becomes director of the Tretyakov Gallery in Moscow; female directors are appointed for the first time at the Tate (Maria Balshaw), the National Gallery of Art in Washington (Kaywin Feldman) and the Musée d'Orsay (Laurence des Cars, later director of the Louvre).

Museums and galleries play catch-up *2020s*

For the first time in its 200-year history, the Rijksmuseum in Amsterdam hangs paintings by women artists in its Gallery of Honour. London's National Portrait Gallery has embarked on a three-year project to enhance the representation of women in its collection. The newly renovated National Museum of Women in the Arts (NMWA) in Washington DC – the world's first and only major museum dedicated exclusively to women artists – has expanded its remit to embrace nonbinary and transgender artists. An entire wing of the Brooklyn Museum in New York is dedicated to feminist art, and the Metropolitan Museum of Art is re-hanging its modern art collection to show work by lesser-known women artists that have never previously been on view. MoMA has launched the Modern Women's Project, highlighting the modern and contemporary women artists in its collection, and the Smithsonian has established Drawn to Art, illuminating women artists who may not have received due attention in their lifetimes.

So, where are we now?

Women painters have a stronger voice than ever before but there is still a way to go before parity with men is achieved in the art world in general. Here is a quick snapshot of how well women are represented in various fields.

Student life *Women outnumber men*
Art schools in the UK and across the pond are dominated by women: in England, women make up 65 to 66 per cent of art students[1], while in the US, they earn 70 per cent of undergraduate fine art degrees.[2]

Working artists *Surprisingly equal footing*
Women are making art and getting paid for it – in pretty much the same numbers as men. In the US, roughly 55 per cent of working artists are women.[3] In the UK, women occupy most artist studios (59 per cent) and receive most funded residencies (63 per cent).[4]

Exhibitions *Showing improvement*
Over the last few years, more women artists have had solo exhibitions in non-commercial galleries in the UK. In 2016, only 35 per cent of exhibitions outside of London and 40 per cent of exhibitions in London were by women artists; by 2021, this figure was at 56 per cent.[5]

Collections *Still pretty dated*
In 1989, the Guerrilla Girls pointed out that while 85 per cent

of nudes in the Met are of women, less than 5 per cent of the Modern Art section are by women artists. Things haven't got a lot better since then: in the US, only 11 per cent of acquisitions are by women artists (and just 0.5 per cent of acquisitions are Black women artists).[6] The UK is equally disappointing: in 2020-2021, only 36 per cent of the artworks acquired by the Tate were by women artists.[7]

Industry *Women are leading the way*
Women tend to be better represented in the senior leadership of museums than in their collections. Of 31 museums surveyed in the US in 2022, 20 have female chief curators or deputy directors; 12 have female directors.[8] In the UK, around 57 per cent of gallery directors are women (though women only make up 33 per cent of directors at major art institutions).[9]

Auctions *Women are not for sale*
Internationally, art by women accounted for just 3.3 per cent of art sold at auctions between 2008 and 2022 (that's $6.2 billion) – for context, this is less than the current market worth of Picasso.[10]

Awards *Winning in recent years*
The first woman won the Turner Prize (the UK's most prestigious contemporary art prize) in 1993; since 2009, 67 per cent of Turner Prize winners have been women.[11] It took 124 years to achieve equality at the Venice Biennale, from the first event in 1895 to 2019, when 53 per cent of the featured artists were women. But just three years later, in

2022, the main galleries, curated by Cecilia Alemani, were made up of approximately 90 per cent women artists (and both the Biennale's top honours went to Black women).[12]

Power *More needed*

42 per cent of the people named on ArtReview's 2023 Power 100 list of 'the most influential people in the contemporary art world' are women – an increase on the last five years and reaching parity, but more work is still needed.[13]

1, 4, 5, 7, 9, 11: Dr Charlotte Bonham-Carter, 'Representation of Women Artists in the UK During 2021' (2022), published by Freelands Foundation: freelandsfoundation.co.uk/research-and-publications/women-artists-report

2: Robert B Townsend, 'Taking Note: How About Those Undergraduate Arts Majors?' (2017), published by the National Endowment for the Arts: arts.gov/stories/blog/2017/taking-note-how-about-those-undergraduate-arts-majors

3: Artist Demographics and Statistics in the US' (accessed 2024), published by Zippia: zippia.com/artist-jobs/demographics

6, 8, 10: Julia Halperin and Charlotte Burns, The Burns Halperin Report (2022), published by Studio Burns Media: studioburns.media/category/the-burns-halperin-report/

12: Charlotte Jansen, 'An Unusual Time for Women at the Venice Biennale' (2019), published by Elephant; Charlotte Higgins, 'Venice Biennale: Women outnumber male artists in the main halls for the first time', published by the Guardian.

13: ArtReview, 'Power 100' (2023): artreview.com/power-100

The
Painters

Hildegard of Bingen

1098-1179

Medieval nun whose visions illuminated the cosmos

Hildegard of Bingen was a German Benedictine abbess, a philosopher, a poet, a scholar of medicine and natural history and a composer of songs that resemble silk unspooling into the dark. Popes and kings wrote to her for advice – and heeded it. She once reproached Emperor Frederick Barbarossa for behaving like 'a little boy or some madman'. Hildegard was a seer, too, blessed with burning spiritual visions that she recorded in a book, *Scivias* – from the Latin 'scito vias Domini' meaning 'know the ways of the Lord'. She laboured over its vellum pages, which include 35 luminous illustrations, for nearly a decade. In ink and gold leaf, the example here evokes the choirs of the angels, 'singing with marvellous voices all kinds of music about the wonders that God works in blessed souls.' Did Hildegard paint it herself? A portrait in the book depicts her holding the medieval drawing tools – a stylus and wax – but it's as likely that the nuns in her charge were involved. If you were a woman with a creative gift, a convent would have been one of the few places in which you might be granted the freedom to flourish.

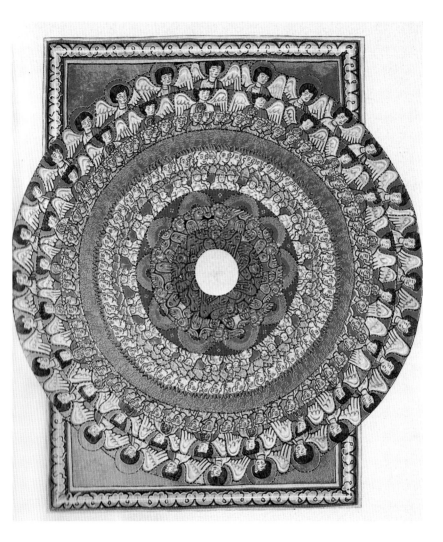

The Choir of Angels

Hildegard of Bingen, miniature from *Liber Scivias*, c.1175,
watercolour on parchment, 32.5 × 23.5cm, Saint Hildegard Abbey

Sofonisba Anguissola

c.1532-1625

Renaissance superstar whose talent
caught the attention of Michelangelo

Rembrandt is usually credited with popularising the self-portrait, but a full century before he first picked up a nub of chalk, the noblewoman Sofonisba Anguissola had painted at least 19. Anguissola was gifted – instructed by Michelangelo; court painter to Philip II of Spain; one of only four women (among 180 men) mentioned in Giorgio Vasari's *Lives of the Artists* (1568) and, at 93, sought out by Van Dyck. Still, when one of her paintings was acquired by Vienna's Kunsthistorisches Museum in 1747, they hung it not in the art galleries, but in the *Schatzkammer* (cabinet of curiosities), beside shark teeth, dragon blood and other rarities. In this self-portrait, she appears with her teacher – Bernadino Campi. She also has three arms, the lowest her own revision, though why she did it (to signify her noble status with gloves? To remove her hand from under Campi's?) is a question that has long since been ignored by men conservators. Not least the one who, in 19th-century Siena, decided to conceal the third arm by repainting her gown in black. No matter that he masked its gold detail, and Campi's paintbrush. While he was at it, he painted out her headband, too. He knew best.

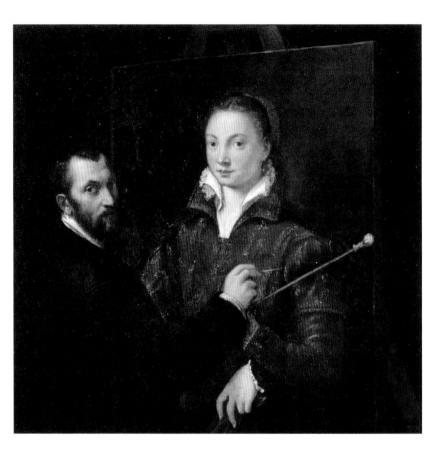

Bernardino Campi Painting Sofonisba Anguissola

Sofonisba Anguissola, 1559, oil on canvas, 111 × 109.5cm, Pinacoteca Nazionale

Lavinia Fontana

1552-1614

Pioneering portraitist of 16th-century Bologna

First things first: the tiny dog. They feature in a great many of Lavinia Fontana's portraits. *Piccolo cane* were a statement of high fashion in 16th-century Bologna and often as ribboned and bibboned as their ornately dressed owners. The city was admired for its silk, and surviving textile scraps show that Fontana copied her sitters' clothing exactly. She was so good at it, a contemporary noted, that she could not cross the Piazza Maggiore without women fluttering about her in adulation. That Fontana attained such stature is a miracle. True, Bolognese women had more latitude than most (its ancient university awarded doctorates to female students as early as the 13th century) but they were still barred from art academies and guilds. Having an artist parent – which Fontana did – was about the only way for a girl to get ahead. And get ahead she did: the first woman to establish her own workshop, the first to be commissioned to paint an altarpiece, often considered the first to paint a female nude. But if her father gave her a start, it was Fontana's talent that maintained it. That and some serious networking: her 11 children counted almost all of Bologna's wealthy elite as godparents.

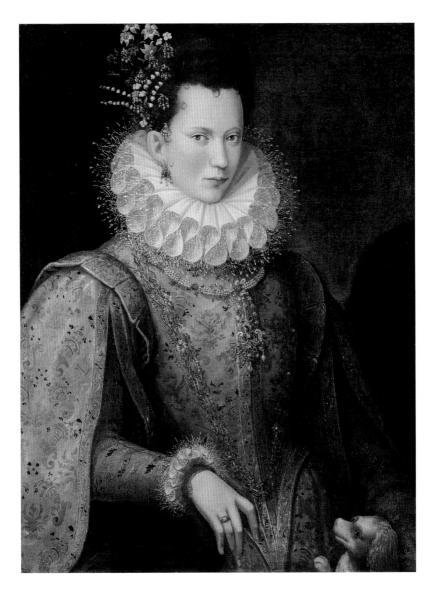

Portrait of a Lady

Lavinia Fontana, 1590s, oil on canvas, 89.5 × 61.9cm

Artemisia Gentileschi

1593-c.1656

Indomitable luminary of the Baroque era

Art was in Artemisia Gentileschi's blood. Her father was the Italian master Orazio Gentileschi, who in 1626 became court painter to Charles I in London. Artemisia helped him paint the ceiling of the Queen's House in Greenwich. She was 33 then, and already internationally renowned, the first woman given membership to the all-important Accademia in Florence. Their Florentine house was 'perpetually full of cardinals and princes, and she is so busy that she barely has time to eat,' her husband complained. Silver spoon, successful career: but Artemisia's life was far from charmed. Three of her five children died in infancy, another at four. When she was 17, she also was raped by her teacher, the artist Agostino Tassi. Artemisia's fame would surpass her father's, but for centuries her assault became the go-to explainer for her paintings, fogging her true accomplishment. Yes, some of her canvases depict power struggles between men and women, but her approach is measured, nuanced – and unusual. She had a rare perspective, she told one patron: 'the spirit of Caesar in the soul of a woman.' Never so irresistible as in this treatment of the beautiful widow Judith and her maidservant, sharing a moment of camaraderie after slaying Holofernes.

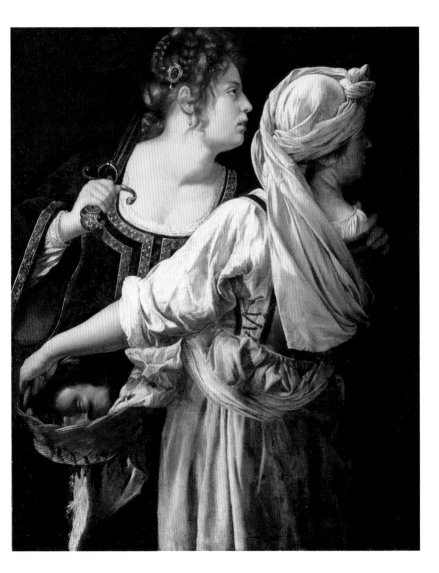

Judith and her Maidservant

Artemisia Gentileschi, c.1615-1617, oil on canvas, 114×93.5cm, Palazzo Pitti

Michaelina Wautier

1604-1689

Old Mistress of the Dutch Golden Age

The identity of this man – a spruce 17th-century gent in the guise of the Biblical shepherd Jacob – has been lost to history. But then, until very recently, so was the artist. Michaelina Wautier, a Flemish painter, was rediscovered in the 1990s, her 30-ish known paintings having passed the previous 350 years under dust sheets in museum stores, or misattributed to other artists. Male ones, as a rule. Often, as with this painting, her brother Charles. She was every bit as good as him though, and well-known for it. In fact, the two – both unmarried – lived and painted together in a Brussels townhouse. Consequently, her career was less hampered by the adversities that most women artists of her time faced: she painted men, for one – some of them as life models. The shepherd here dates from the highpoint of her career, in the mid-1650s. The way she positioned him was a daring departure from tradition – at a right angle to the picture plane, with a shoulder turned towards the viewer. It lends him real dynamism – he is almost in motion – and has the frisson of a frank encounter.

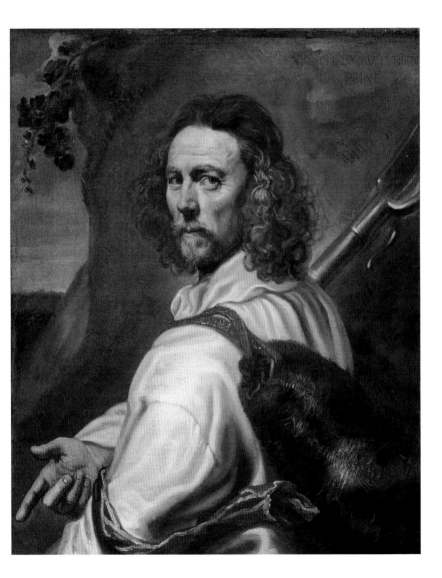

Jacob

Michaelina Wautier, c.1655-1660, oil on canvas, 62 × 76.5cm

Rachel Ruysch

1664-1750

Still-life virtuoso and the first female
member of the artists' society Pictura

To call the Dutch Golden Age artist Rachel Ruysch a success does her a disservice. At a time when most cloth-workers earned less than a guilder a day, she could sell a painting for 1,200. Even Rembrandt only managed 500. Daughter to the botanist and anatomist Frederik Ruysch, grandniece of the landscape painter Frans Post, granddaughter of the Dutch imperial architect Pieter Post, her beginnings were propitious. She learned still life from Willem van Aelst, Amsterdam's premier painter of game and flowers, but developed a passion for the dark *sottobosco* (forest floor) paintings collected by her father. She swiftly gained acclaim, both for her botanically impossible combinations (she mixed seasonal plants with preserved species from her father's famed cabinet of curiosities) and her incredible realism, achieved with a very fine brush and by dipping real moss and butterfly wings into paint, in the manner of stamps. Her ten children didn't slow her down: in 1699, she became the first woman member of the artists' society Confrerie Pictura, and in 1708, court painter to Elector Palatine Johann Wilhelm II. Nor did old age: to this flower painting from 1748, she proudly added her age beside her signature – 83.

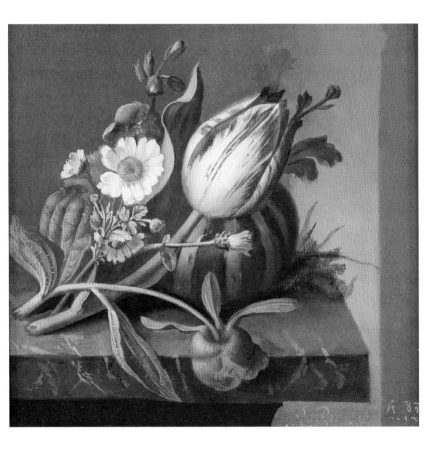

Still life of a tulip, a melon and flowers on a ledge

Rachel Ruysch, 1748, oil on oak panel, 16 × 17.5cm

Angelica Kauffman

1741–1807

History painting from a female perspective

Angelica Kauffman was 25 when she came to London in 1766, a prodigy in her native Switzerland. What happened next is magical: in defiance of convention, she turned herself into one of the foremost neoclassical portrait painters of Georgian London. Her influential sitters made her rich, but her sights were set higher: history painting, then the most respected genre. It was unheard of for a woman, and Kauffman did it in style, dismissing the idea that only male heroes were worthy subjects and sending the Establishment into frenzies of delight in the process. More particularly, their wives: when she wasn't painting Helen of Troy or Cleopatra, Kauffmann was painting Lady this and Baroness that in the guise of Helen of Troy or Cleopatra. Her most dedicated admirer was Sir Joshua Reynolds, founding President of the Royal Academy, who was 'never done of praising me to everyone.' Gossip hounds suggested the admiration was more than artistic, and who knows? His patronage probably helped her election to the Academy – Kauffman was one of just two female Founder Members – but her radiant paintings played equal part. As did her popularity: by 1761, the market for scenes 'after Kauffman' on snuff boxes and furniture caused one engraver to exclaim that 'The whole world is Angelicamad.'

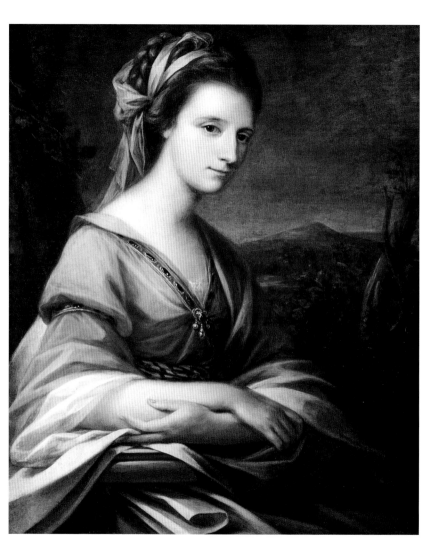

Lady Frances Greville (1744-1825), Lady Harpur

Angelica Kauffman, 1767, oil on canvas, 76 × 63.5 cm

Élisabeth Louise Vigée Le Brun

1755-1842

Marie Antoinette's favourite portraitist

When Élisabeth Vigée Le Brun fled the French Revolution – her paintbrushes and little else in one hand, her six-year-old daughter clutching the other – she was court artist *du jour*, with 30 portraits of Queen Marie Antoinette under her belt. Her father, a pastelist, had been her teacher, though her talent far outshone his. *Comtesse de la Châtre* – daughter to Louis XV's valet, niece and heir to Louis XVI's banker – was one of the last portraits that Vigée Le Brun completed before going into exile. It was commissioned by the married Comtesse's lover, the Comte de Jaucourt (they wed when France introduced divorce laws in 1792). Quite a story, yet the real lure of the painting is its tissue of touches: green velvet, black ribbon, sprigged muslin – the latter in a style popularised by Marie Antoinette, so signalling the Comtesse's fealty. Even in exile, cut off from her husband and the support of Versailles, Vigée Le Brun prospered. From Naples to Rome, Bologna, Vienna, Saint Petersburg and – from 1802 – Paris again, her services were always sought-after, her blue-blooded clientele assured.

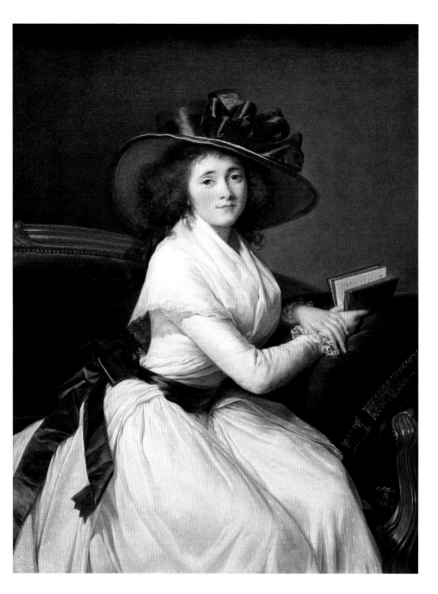

Comtesse de la Châtre

Élisabeth Louise Vigée Le Brun, 1789, oil on canvas, 114.3 × 87.6cm, Metropolitan Museum of Art

Sarah Biffin

1784-1850

Accomplished miniaturist who painted with her teeth

'In a commodious booth, opposite The Bell,' announces an
1810 handbill, 'the wonderful Miss Biffen [sic] will be exhib-
ited.' Biffin, an exceptionally talented artist born without
arms, was placed under contract with showman Emmanuel
Dukes, touring all England as a fairground attraction to be
gawped at. In her booth, she cut out and sewed clothes, but
she was most famous as a painter, able to 'Paint Miniatures,
and many more wonderful Things' holding the brush in her
mouth or pinned to a puff sleeve. The Earl of Moreton, who
sat for a portrait at St Bartholomew's Fair, was so astonished
that he sponsored Biffin's formal training with painter
William Marshall Craig. The still life here dates from that
time. In 1821, she opened a studio on the Strand, earning
her living as a miniaturist and teacher. Georges III and IV,
William IV, Victoria and Prince Albert were among her
patrons. Biffin was less lucky away from the easel: a brief
marriage ended when her husband made off with her savings.
Loyal friends came to the rescue with an annuity, including
the singer Jenny Lind – though Dickens, who refers to Biffin
in four novels, declined.

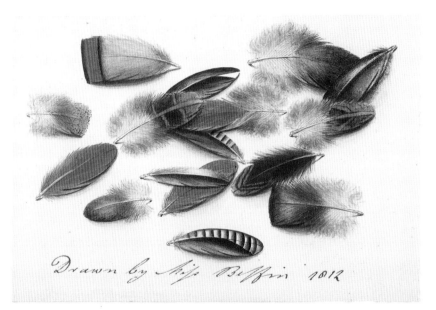

A Study of Feathers

Sarah Biffin, 1812, pencil and watercolour on paper, 10.1 × 15.2cm, Philip Mould Gallery

Amalia Lindegren

1814-1891

Admitted to the Swedish Academy 17 years
before they officially accepted women

'She doesn't paint in the fussy way women usually do' – high praise indeed for the painter Amalia Lindegren from Sweden's leading newspaper. The editorial, published in 1853, was prompted by a picture that Lindegren sent to the Swedish Art Academy (of a man in a tavern, which probably contributed to the journalist's surprise), after winning a state scholarship to study art abroad. Naturally she'd chosen Paris, and naturally she'd had to bring a chaperone: unmarried women were still 'minors' in the eyes of Swedish law. Lindegren, though, was not minor at all. Admitted to the Academy in Sweden as an 'extraordinary student' in 1849, she was voted an 'associate member' by 1850, when she painted this beautiful nude. It would be another 14 years before the Academy, then the only art school in Sweden, accepted women as regular students – and it was Lindegren's international success that ushered in the change. When she eventually returned from Paris, she rented herself a studio and set up as a genre painter and portraitist. King Carl XV of Sweden and his wife Lovisa sat for her in 1859, after which she was so famous that, when a painting of hers was shown at the Chicago World's Fair in 1893, the crowds queued three-deep.

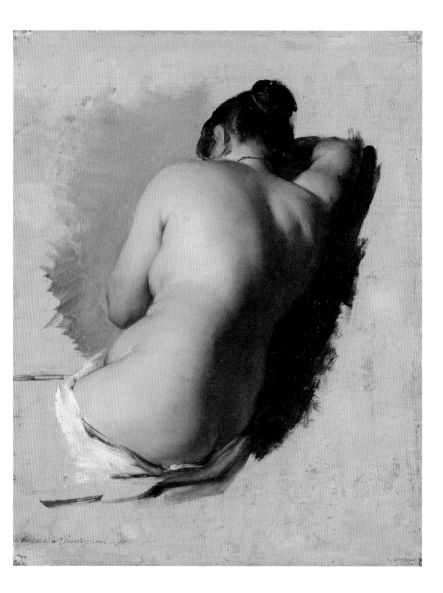

Study of a Nude

Amalia Lindegren, c.1850, oil on canvas, 33.5×26.5cm, National Museum of Fine Arts, Stockholm

Berthe Morisot

1841-1895

The only female founding member of the Impressionists

A woman interrupted at her sewing, the Normandy resort of Fécamp unfurling behind her. I could stare for hours at that radiant, milk-silver sea; the thousands of flickering brush-strokes surrounding it. It's a modest subject for a painting, but Berthe Morisot was a master of modest. Her art is one of private spaces – apartments, villas, enclosed gardens – though she saw subtleties in them that everyone else failed to notice. 'My ambition was limited to wanting to capture something of what goes by, just something, the smallest thing,' she said. A founding member of the Impressionist group, she was the only woman to contribute to their first exhibition in the spring of 1874. She painted this picture that summer, while holiday-ing with her sister and the Manets. The families were friends and Morisot, it is rumoured, was the artist Edouard Manet's mistress. It was during this trip that she became engaged to his brother, Eugène. *On the Terrace* depicts a friend, Madame Boursier. Belted sensibly into her travelling coat, listening intently to the artist's chatter, she is utterly present, brimming with inner life and a world away from the ribbon and lace vapidity of most Impressionist beauties.

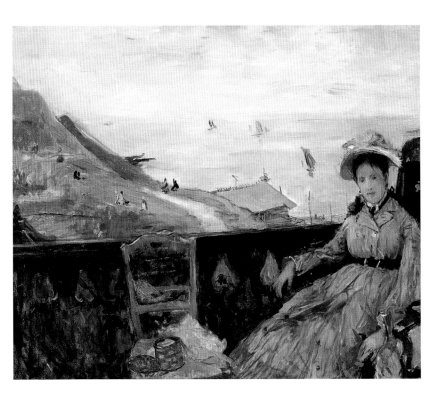

On the Terrace

Berthe Morisot, 1874, oil on canvas, 65.5×73cm, Tokyo Fuji Art Museum

Mary Cassatt

1844-1926

*Perceptive painter of women and children
– and Degas' soulmate*

Mary Cassatt's arrival in Paris coincided with the first Impressionist exhibition in 1874. She quickly became an insider: one of just four women and the only American they invited to exhibit with them. Cassatt was no ingénue – she'd been exhibiting at the Salon (scourge of anything radical) since 1868 – but she was pleased to be asked and, she admitted, relieved to be free of the Salon Jury. 'At last, I could work with absolute independence,' she said. 'I hated conventional art. I began to live!' Pissarro admired her technical skill, Gauguin her charm and strength, but it was Degas who became her true mentor – and lifelong friend. 'This is someone who feels the way I do,' he said. For a time, the two went out sketching together, at the theatre or in the galleries of the Louvre, but when her sister was diagnosed with terminal kidney disease, Cassatt changed tack, painting only her extended family in their private sphere. Women and children were her special focus – the way she captured them subtle and sensitive. Short-sighted critics dismissed them as the dalliances of a 'lady painter' but she sold enough of them to buy herself a vast chateau in the countryside north of Paris.

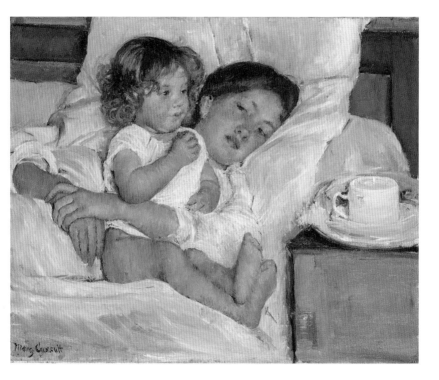

Breakfast in Bed

Mary Cassatt, 1897, oil on canvas, 58.4 × 73.7cm, Huntingdon Library, Art Museum, and Botantical Gardens

Harriet Backer

1845-1932

Interiors exploring the effects of light and colour

Harriet Backer is one of only three Norwegian artists to have a dedicated room at the Nasjonalmuseet, Oslo. The other two are men, and one of them – I hardly need tell you – is Edvard Munch. On home soil, she always received due attention, her opinion sought by gallery acquisition and judging committees at a time when women elsewhere were struggling to vote at all. She exhibited internationally, too, though her standing diminished after her death. Her great passion was interior scenes, less to depict life unfolding than as a stage set where she might let loose her feeling for stone, glass and, above all, light and colour – a wall is rouged by a lamp, or gilded by the sun. Ten years in Paris played a part, since her stay coincided with the reign of the Impressionists, of whom Monet was her particular favourite: 'Such air and light and distance and decorative effect in his paintings,' she said. *Blue Interior* was her breakout painting, with one critic likening it to Vermeer. Painted in her Paris apartment, the title refers not just to the room's decor and the sitter's dress, but also to the beautiful, etherised quality of the shadows.

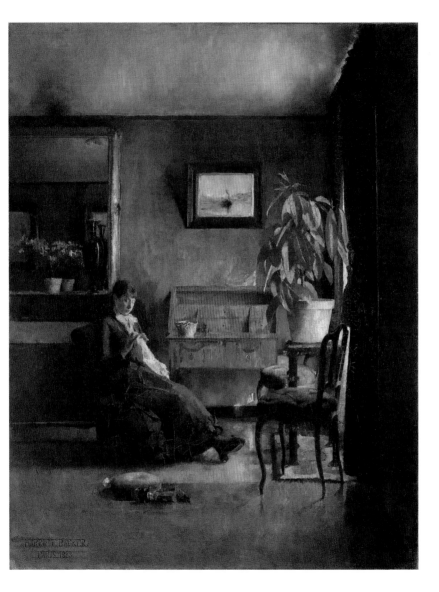

Blue Interior

Harriet Backer, 1883, oil on canvas, 84×66cm, Nasjonalmuseet

Julia Beck

1853-1935

Swedish painter of aqueous plein air landscapes

In the 1880s, the French village of Grez-sur-Loing reeled in
hundreds of artists, among them the Swedish painter Julia
Beck. They came seeking its aqueous light and its freedoms,
not least from the sludgy brown realism taught in the insti-
tutional Academies. On the banks of the Loing, artists took
risks, painting outside *en plein air* and disregarding the rules
concerning pictorial space and colour. The presence of celeb-
rity writers, such as Robert Louis Stevenson, was also a draw.
Stevenson recalled the village in an 1892 travel memoir, its
'islanded reed-mazes... the mirrored and inverted images of
trees; lilies and mills and the foam and thunder of weirs.' He
could have been describing Beck's canvases. She painted the
river in all lights, weathers and seasons, its shimmering sur-
face dotted with water lilies drifting in reflections of clouds
and trees. Like Monet, she would have seen the flower's
cross-pollinations presented by horticulturalist Joseph Bory
Latour-Marliac at the Paris World Fair in 1889 – her paint-
ings represented Sweden that year, even if her soul had long
been lost to France. In 1888, she bought a house on the river
Seine, devoting the rest of her life to its 'misty atmosphere...
the sun glittering in the haze.'

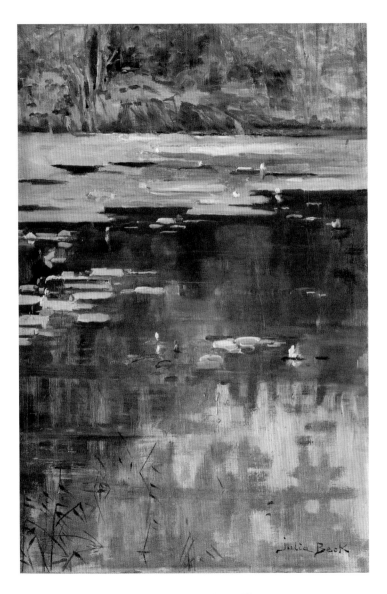

River Landscape with Water Lilies

Julia Beck, 1880s, oil on canvas, 55 × 38cm

Anna Bilińska

1854-1893

Polish portraitist fuelled by grief

Anna Bilińska journeyed from a remote outpost of the Russian Empire to win the admiration of audiences worldwide. Her remarkable ascent, and her determination to establish an art school for women, were cut short by her premature death. Portraits were her speciality. She perfected them at the Académie Julian in Paris, though poverty kept her in lodgings that would scarcely fit more than a small bed and a chair. This one – a self-portrait – was her first success. It was radical for its time, partly because she posed herself in front of a backdrop more suited to a nude model, partly due to her scandalously dishevelled hair. The painting really unfolds, though, when you learn that Bilińska made it in the wake of three deaths: her father, her best friend and her fiancé in the space of two years. This is her emerging from grief, transformed. Everything about it expresses a wish to be taken seriously, and she was: a gold medal at the Salon, exhibitions in London, Berlin (another gold medal), Kraków and Warsaw. She sold more than a hundred works between then and 1892. The same year, she was commissioned to make another self-portrait, but died before she finished it, at just 36. Her husband, the doctor Antoni Bohdanowicz, thought the painting cursed.

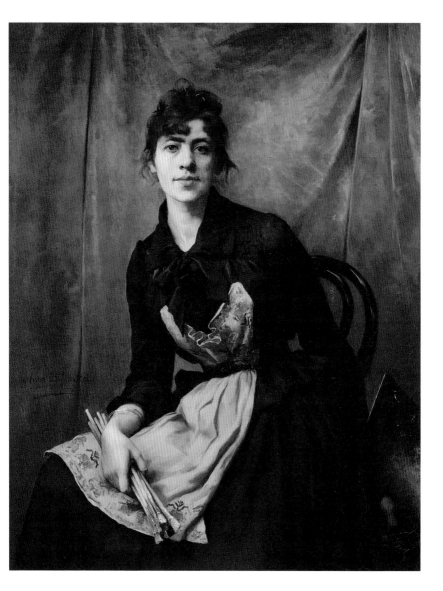

Self-Portrait with Apron and Brushes

Anna Bilińska, 1887, oil on canvas, 117×90cm, National Museum, Kraków

Cecilia Beaux

1855-1942

Portraitist of distinction to American high society

In her day, Cecilia Beaux was thought the equal of John Singer Sargent, celebrated for her portraits of America's East Coast elite. 'Not only the greatest living woman painter, but the best that has ever lived,' according to the artist William Merritt Chase, though Beaux would have bristled at his compliment – she hated the qualifier 'woman'. She financed her studies by sketching palaeontological specimens for the US Geological Survey, and won international attention with an 1883 oil painting of her sister and nephew, after which she travelled to Paris to refine her technique at the Académie Julian. Or tried to – she found its packed studio insufferable, the relentless critiques a test of her will. 'You know how I hate to fail,' she wrote home, 'my grip is pretty hard as a rule'. Five years following her return, she had racked up something like 40 portrait commissions. Mr Drinker here, with his magnificent whiskers, was her brother-in-law, and the engineer responsible for the two-mile long Musconetcong railway tunnel linking Pennsylvania and New York. In the tension of his hand and the look of what might be admiration in his steady gaze, Beaux gives every intimation of his character. He transfixes us, as she appears to have transfixed him.

Man with the Cat (Henry Sturgis Drinker)

Cecilia Beaux, 1898, oil on canvas, 121.9 × 87.8cm, Smithsonian American Art Museum

Anna Mary Robertson Moses (Grandma Moses)

1860-1961

Bucolic folk painter of 'old-timey' America

When Anna Mary Robertson Moses took up painting in 1936, she was already 76 years old with 30 great-grandchildren. Nevertheless, she turned her arthritic hands from quilting and embroidery to painting happy scenes from her life in rural New York and Virginia. What happened next is magical. Against the odds, she became an international celebrity, helped by the civil engineer and art collector Louis Caldor, who saw her paintings in a drugstore window – displayed with her hooked rugs, preserves and crocheted doilies. Impressed by their primitivist style and 'old-timey' subject matter, he bought the lot. He then arranged for her inclusion in a 1940 exhibition of self-taught artists at MoMA (this was despite her devotion to glitter; nothing beat it to suggest snow in sunlight, she insisted). A critic for the *New York Herald Tribune* referred to her by her neighbours' nickname 'Grandma Moses', and it stuck. Before long, her paintings were reproduced on stamps, fabrics and greeting cards. In 1949, she was invited to Washington to receive an award from President Truman, and by 1960 had made the covers of *Time* and *Life* magazines. When she died, at 101, her body of work amounted to more than 1,500 paintings.

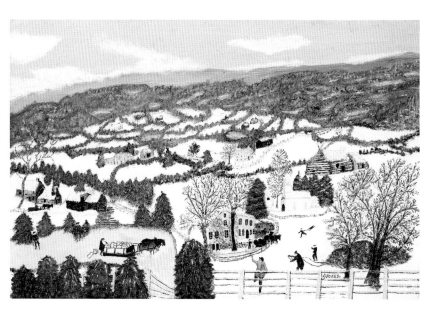

Help

Anna Mary Robertson Moses (Grandma Moses), 1956, oil on masonite, 40.6×61cm

Hilma af Klint

1862-1944

Occult-inspired pioneer of abstract art

Before Hilma af Klint died, she stipulated that her 1,200-odd paintings and 26,000-ish pages of notes be kept from the public for 20 years: the world was not ready to understand them. She got her wish and more, because her work remained all but unseen until 1986, and only received serious attention much more recently. In 1890s Stockholm, af Klint was widely respected as a figurative painter. Her abstract pieces, in the form of huge, pastel-coloured canvases, came later – about 1906 – but still predated abstraction's so-called pioneers, Wassily Kandinsky, Kazimir Malevich and Piet Mondrian. Where those men trumpeted their discoveries, af Klint kept her ground-breaking paintings largely private. That's because they were generated through her practice as a medium. Every week she and four other women artists conducted séances. They called themselves The Five and are thought to have been artistically collaborative. The painting here, part of a series depicting the four spiritual ages of man, was 'commissioned' by an entity named Amaliel. 'I worked swiftly and surely, without changing a single brush stroke,' said af Klint. Even after the work was done, though, the spirits never let up and the labour of understanding them and expressing an invisible realm, took all her life.

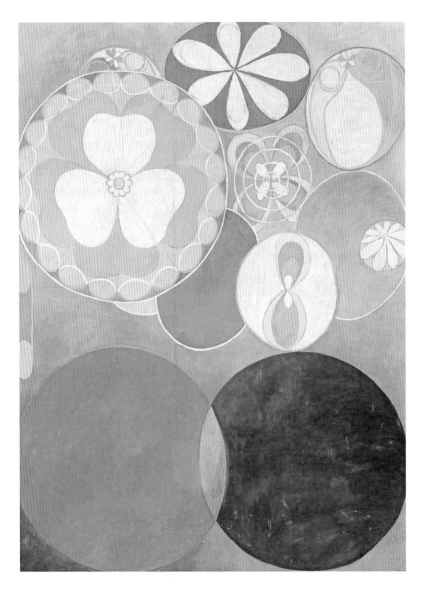

The Ten Largest, Group IV, No. 2, Childhood

Hilma af Klint, 1907, tempura on paper, mounted on canvas, 315 × 234cm

Suzanne Valadon

1865-1938

Montmartre model turned bold and sensuous painter

Before she became a painter, Suzanne Valadon was an art-
ists' model in Belle Époque-era Paris – to Impressionist lumi-
naries Renoir, Degas and Toulouse-Lautrec, no less. Also a
circus acrobat, or so she liked to say. The French capital was a
powerful stew of glitter, decadence and unrest at the time, and
Valadon dove into it headfirst. Her paintings – vital, subver-
sive, epicurean – reflect this. She produced *The Blue Room*
when she was in full sail. It's a twist on the 19th-century fad
for *odalisques* (concubines displayed in opulent, Oriental-style
interiors) that had been a favourite subject for countless art-
ists, including Ingres and Matisse. Hardly any of them had
actually travelled to the Near and Middle East (and wouldn't
have been allowed inside a harem if they had), so their inter-
pretations were blends of hearsay and invention; their women
erotic ideals loosely dressed in translucent clothing. Not in
Valadon's version, which relishes the way a woman's flesh
swells and settles. Her model's slouch, bored look and mot-
tled skin are a world away from Ingres's smooth-skinned
coquettes. As important are the props and 'stuffs' – silk so
crisp it seems to crackle, a serious-looking book, that marvel-
lous drooping cigarette. Few artists come close in spiritedness
or humour.

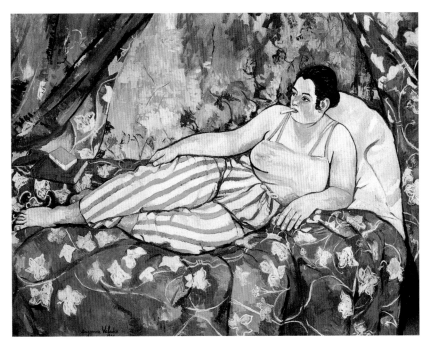

The Blue Room

Suzanna Valadon, 1923, oil on canvas, 90 × 116cm, Musée National d'Art Moderne

Aurélia de Souza

1866-1922

Piercing portraits made in a haunted Portuguese mansion

After three glittering years studying art in Paris – and a homecoming tour that took in Amsterdam, Venice, Rome, Florence, Seville and Madrid – Aurélia de Souza returned to her family's estate in Porto, Portugal, and never left. She and her three sisters lived a secluded life. The house, an 18th-century villa on the banks of the Douro, was huge; its upkeep a Sisyphean struggle. It was jostling with ghosts, too – the girls avoided walking from one wing to another after dark. What it did have, though, was plenty of space for a painting studio, and de Souza painted ceaselessly: still lifes stocked with fruits and stems cut from the garden and sweeping, French-style views painted outdoors. That she rode her bicycle deep into the hills in unusual clothes to find them made her a local curiosity. But if de Souza had a gift, it was for portraits. Her paintings of her sisters and their friends, and the heroic, hard-working poor of Porto have a depth that can be as unsettling as it is absorbing. The face is always her focus and her self-portraits easily the most startling. See here how the oversized bow frames and emphasises her strong, determined expression; her piercing, all-seeing eyes.

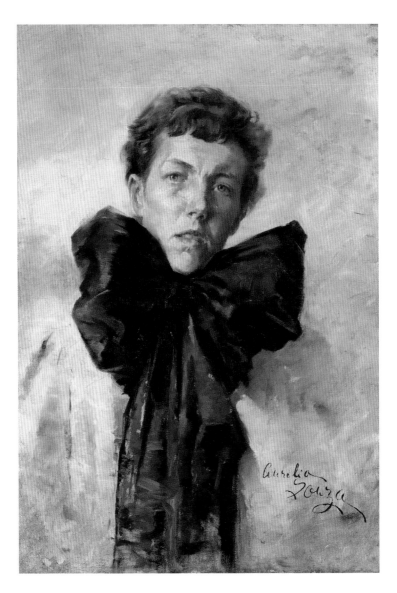

Self-Portrait "with black bow"

Aurélia de Souza, c.1895, oil on canvas, 67.5 × 47cm, Collection José Caiado de Souza

Mabel Pryde

1871-1918

Forgotten member of the Nicholson art dynasty

Mabel Pryde Nicholson is so present in her paintings, so absent in every other way. Her story has been overshadowed by the artistic success of the men in her family: her husband William Nicholson (Edwardian society portraitist), and sons Ben (pioneer of British abstraction) and Kit (modern architect). She met William at art school, where her paintings outclassed his and every other student's in the room, and earned some notoriety for spiritedness. Like most women of her time, however, she put aside painting upon marriage and when she did return, fitted it in around other responsibilities. She painted what was easily at hand: her children, though she genuinely seems to have adored spending time with them and all four were devoted to her in return – certainly her paintings show great strength of feeling. Many feature costumes or stage set-like devices (she was theatre-mad), and *The Grange, Rottingdean*, of her daughter Nancy with Kit in their Sussex bolthole, is a beautiful example. That she rose by leaps and bounds – exhibiting in London and earning enough from the sale of a single painting to commission Edwin Lutyens to build her a studio – makes her sudden death, at 47, all the more distressing. Things were really just beginning.

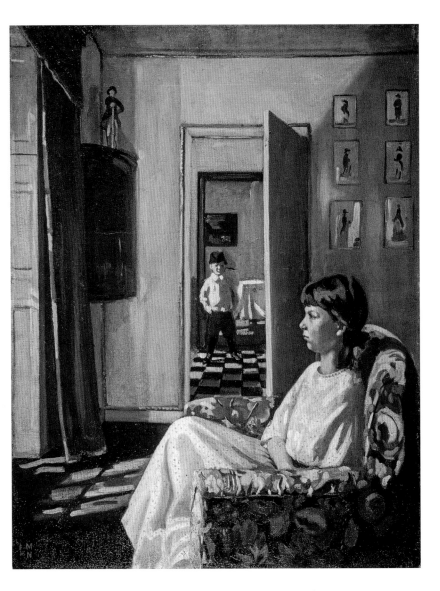

The Grange, Rottingdean

Mabel Pryde, 1911, oil on canvas, 91.5 × 72.5cm, National Galleries of Scotland

Emily Carr

1871-1945

Evoking the Indigenous culture of the Pacific Northwest

Emily Carr's intrepid sketching trips to the remote First Nation villages of British Columbia are legendary in her native Canada. Her compulsion to record them was perhaps amplified by the long shadow of the smallpox epidemic that had killed swathes of Indigenous people in the 1860s. In her paintings of this wilderness, she tried to infuse Modern art with the spiritual force she recognised in Indigenous monuments, such as poles carved from giant cedars. 'These things,' she said, 'should be to Canadians what the Ancient Britons' relics are to the English'. She sought to challenge Canadians' understanding of their homeland, a task for which her rebellious spirit was eminently suited: she was content to thin her paint with cheap gasoline, and boycotted by the Ladies Art Club in Vancouver for smoking and cussing. In 1929, she sketched this small mission church in the village of Yuquot, but the painting feels more about the wall of forest behind it. The church is out of place and unbudging, the trees all rhythm and dark roll. 'Movement is the essence of being,' she wrote. 'If there is no movement in the painting, then it is dead paint.'

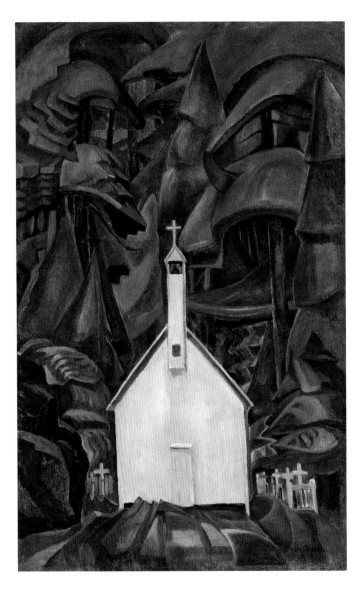

Indian Church

Emily Carr, 1929, oil on canvas, 108.6 × 68.9cm, Art Gallery of Ontario

Uemura Shōen

1875-1949

Saluting the inner lives of ordinary women

Uemura Shōen became famous in her native Japan at the age of 15, when her painting *The Beauty of Four Seasons* was purchased by a son of Queen Victoria, then on royal tour. She specialised in *bijin-ga* (pictures of beautiful women) – a genre traditionally confined to blank-faced courtesans and princesses, but which Shōen redeployed to show real women with inner lives, emotions and a degree of self-reliance. She was fiercely independent herself, refusing to marry or name her children's father (rumoured to be her teacher). Her strength seems to have come from her upbringing, and especially her widowed mother, who ran a teashop in Kyoto and supported her daughter's unconventional decision to go to painting school. 'My mother, who gave birth to me, also gave birth to my art,' Shōen said. She also painted women from traditional Japanese dramas, here Akizuki Miyuki, heroine of *The Tale of Morning Glory*. Miyuki has just received a fan from the Samurai Miyagi Asojiro, on which he declares his love for her; she has hidden it in the sleeve of her kimono – you can just see its concertina black folds in the ripple of decorated silk.

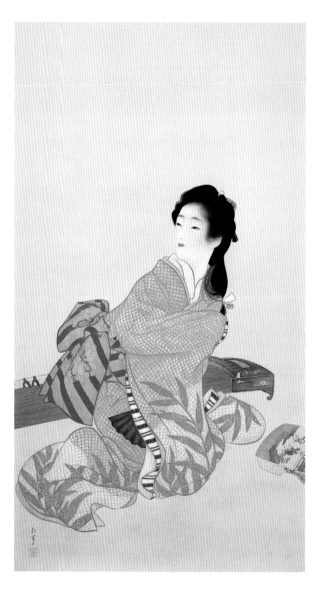

Daughter Miyuki

Uemura Shōen, 1914, ink on silk, 153 × 84cm, Adachi Museum of Art

Gwen John

1876-1939

Modernism's lone wolf

Her work is part of early modernism, but Gwen John pursued her own, somewhat irregular path through that era's clashing innovations. In Paris, where she studied in 1899 and moved to in 1904, she met Picasso, Braque and Matisse, and looked thoughtfully at Cubism, Futurism and Abstraction, but remained more or less untouched by them all. Admired by James McNeill Whistler for her 'fine sense of tone', her delicate paintings – mostly simple portraits and interiors – suggest a timorousness that belies her spirited single-mindedness. She fought her father to study at the Slade School of Fine Art, and set out to walk from London to Rome with her friend Dorelia. They slept in fields and paid their way by singing and selling drawings (though gave up 150 miles in, at Toulouse). *Portrait of a Lady* depicts another friend, Grilda Boughton-Leigh, with whom John studied at the Slade. It's one of eleven known drawings from a single sitting. Rejecting the careful modelling that would have been impressed upon her in art school, the lightly worked drawing still beautifully captures Boughton-Leigh's miscreant hair and searching expression.

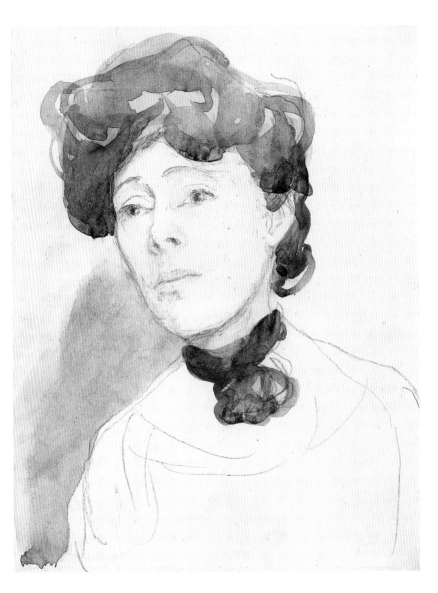

Portrait of a Lady

Gwen John, 1909-1910, pencil and grey wash on paper, 20.3 × 15.5cm

Laura Knight

1877-1970

Force of nature who painted women as they are

In this self-portrait, Laura Knight paints herself painting a model – her friend Ella Louise Naper. The Napers were neighbours in Cornwall, where between 1907 and 1919 Knight and her husband lived as part of an artists' colony; a time of 'sunlight pleasure', she recalled. It's hard to understand why this picture incited such fluster when it was first shown, declared 'dangerously near to vulgarity' by *The Daily Telegraph*. Knight, the critic grumbled, had failed to embellish either herself or her model with the 'charm of the "eternal feminine"'. As late as 1939, *The Times* called the painting 'regrettable'. Knight hadn't exactly courted the opprobrium, but she had intended to make a point. At Nottingham School of Art, she had had to make do with plaster casts while her male cohort painted nudes from life. She believed the restriction had hindered her artistic development, and a decade later felt bold enough to risk doing something about it. Besides, beyond the dustier corners of Britain, this portrait seemed only fresh and exultant, and Knight one of the most attentive, interesting painters of her day. Sure enough, in 1929 she became a Dame, and five years later was the first woman elected a full member of the Royal Academy since 1768 (p.30).

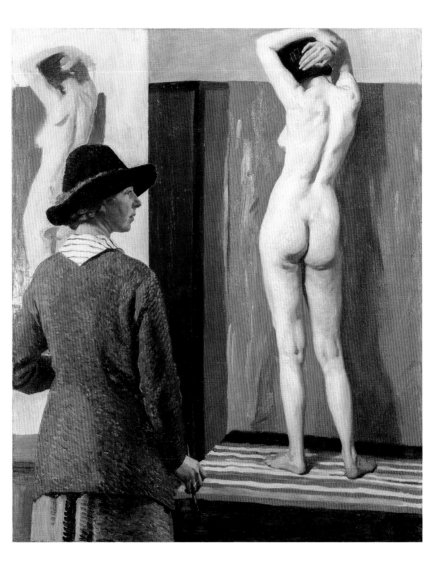

Laura Knight with model, Ella Louise Naper ('Self Portrait')

Laura Knight, 1913, oil on canvas, 152.4 × 127.6cm, National Portrait Gallery, London

Vanessa Bell

1879-1961

Post-Impressionist at the heart of the Bloomsbury Group

Vanessa Bell painted four portraits of her sister, the author Virginia Woolf, in 1912. It was a significant year for both of them: Woolf had nearly finished the final draft of her first novel, and four of Bell's paintings had been selected for Roger Fry's landmark Second Post-Impressionist Exhibition, where they hung on the silk-papered walls next to Picasso and Matisse. Bell often chronicled her household, which became a focal point for the luminous circle of avant-garde artists and writers known as the Bloomsbury Group. In rooms 'full of smoke [with] buns, coffee and whisky strewn about,' Woolf wrote, 'we were full of experiments and reforms… everything was going to be different. Everything was on trial.' The two sisters were particularly tight, and had been so since their suffocating patriarchal Victorian childhood, forming what Woolf described as 'a close conspiracy… our private nucleus'. We feel that connection in the painting here, of Woolf lazing into an armchair with her knitting; the indistinctness of her features both an indication of Bell's response to modernism's ranking of colour and form over subject, the close quality of the sisters' relationship and – perhaps – Woolf's fatal inscrutability.

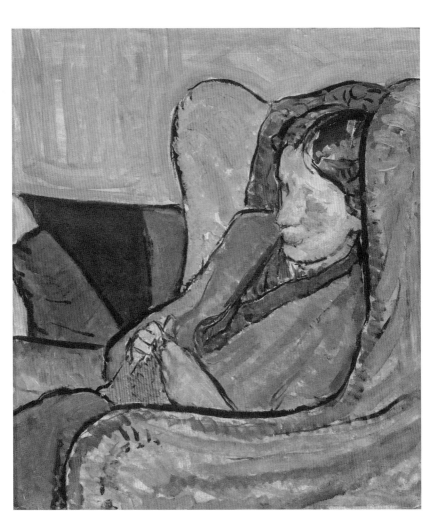

Virginia Woolf

Vanessa Bell, 1912, oil on board, 40 × 34cm, National Portrait Gallery, London

Madeline Green

Costumes and characters that challenge gender norms

Bathed in the thin light of winter, two women sit side by side. The one on the right – British artist Madeline Green – has her hair stuffed into a cap and wears a jacket and trousers, both rumpled and oversized. *So what*, says her face and the hand on her waist, though her more conventionally dressed companion is perhaps less sure. Green developed multiple characters like these for herself and her sister, Gladys, who lived with her at her west London studio. Many of her paintings feature its 'strange pale interior,' as the magazine *Le Petit Parisien* described the room – admiringly – in 1925. Though her oval face and wide-eyed look are instantly recognisable, Green's costumes and characters (dancer, costermonger) resist the idea of a fixed identity or 'norm', her paintings a response to rapidly changing ideas about womanhood in the interwar years when the New Woman – a creature for whom marriage was optional and independence a must – triggered mass anxiety. Green, who learned from society portraitist John Singer Sargent at the Royal Academy Schools and exhibited prolifically thereafter, could convey introspection like nothing and nobody else. See how her figures meet our eyes, yet give almost nothing away.

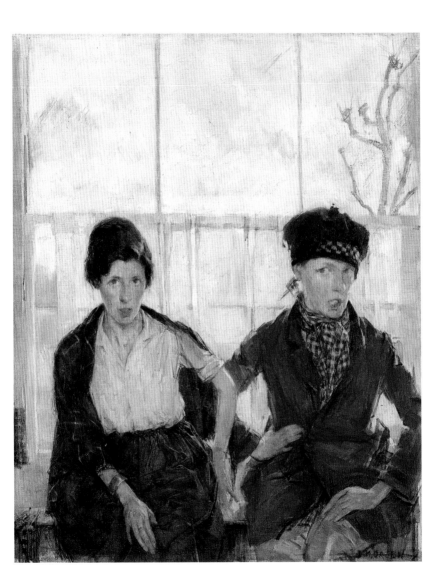

Glasgow

Madeline Green, c.1930, oil on canvas, 53.6×43.3cm, National Gallery of Victoria

Zinaida Serebriakova

1884-1967

Spirited Russian painter forced into lifelong exile

In 1924, Zinaida Serebriakova left her four children with her mother in Russia and travelled to Paris to fulfil a mural commission. Since the Bolshevik Revolution of 1917 and the arrest and death of her husband the following year, she had struggled to make ends meet: the rosy neoclassicism of her paintings deemed out of whack with the propagandist style prescribed by the Soviet government. From a high-ranking family of creatives, Serebriakova had been mentored by Ilya Repin, the so-called 'Rembrandt of Russia'. Her early paintings were of the landscape near her family home in Neskuchnoye (now Ukraine), of bathers and dancers, and her children – not posing, but going about their little lives: eating bread rolls, making a house of cards and so on – and self-portraits like this one. When she tried to return from Paris, however, restrictions had tightened, and she was refused. Russian émigrés in France provided enough portrait work to send money to her children, but during the Nazi occupation she had to renounce her citizenship and, along with it, hopes of reuniting with her family. It wasn't until 1965 that the Soviet government permitted her return. A trio of exhibitions organised by one of her daughters the following year was a triumph.

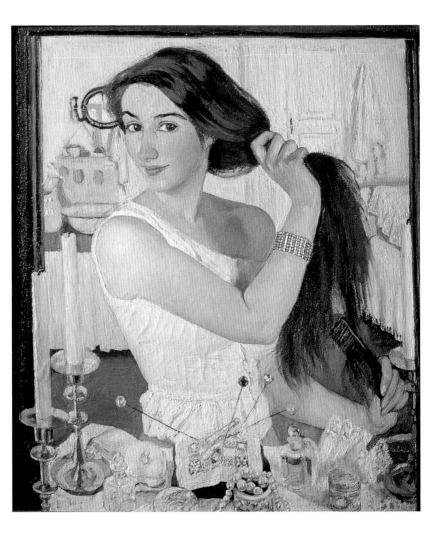

Self-Portrait at the Dressing Table

Zinaida Serebriakova, 1909, oil on canvas, 75×65cm, Tretyakov Gallery

Sonia Delaunay

1885-1979

*Avant-garde colourist who took
the art and fashion worlds by storm*

Within a year of arriving in Paris from Ukraine in 1905, Sonia Terk's colourful, heavily outlined portrait paintings had been exhibited with the likes of Pablo Picasso and Georges Braque. Her pioneering modernist canvases, though, were only part of her achievements: she directed her considerable feeling for colour – 'the skin of the world,' as she once described it – into fashion, advertising posters, stage costumes, even a car. She even named her own hues, such as cactus (green) or capucine (orange), and, with her husband, the artist Robert Delaunay, patented the concept of *simultanéisme*, where contrasting colours are set alongside each other to create rhythm and movement. In the 1920s, their apartment near the opera house was a honeypot for the Parisian and foreign avant-garde – she spoke Russian, French, German and English and was well-read in all four. After Robert died in 1941, she returned to her easel with vigour, painting coloured circles in endless abstract formations. Filled in or outlined, full and halved, they reel back and forth across her canvases. President Georges Pompidou chose one of them as a gift for Richard Nixon when he visited him in Washington in 1970.

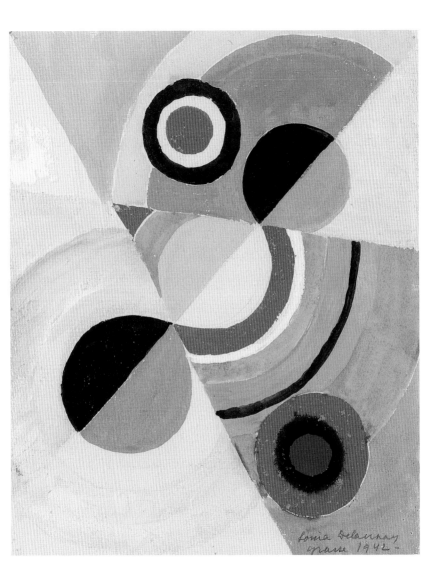

Composition Simultanée

Sonia Delaunay, 1942, gouache on paper, 27.2 × 22.1cm

Georgia O'Keeffe

1887-1986

Groundbreaking painter of music-inspired abstractions

Georgia O'Keeffe was the first woman granted a solo retrospective by MoMA New York. She was 59 then, and one of America's most successful artists, known for her paintings of skyscrapers and her larger-than-life close-ups of bones, shells and flowers. 'I will make even busy New Yorkers take time to see what I see,' she said. These and the landscapes she later produced in New Mexico remain her best-known works, yet late in life O'Keeffe intimated that her most accomplished paintings were those she had made before she was famous, while making a living as a teacher in Texas and in her first hungry weeks in New York. Her preoccupation in those years was 'the idea that music could be translated into something for the eye,' as she described it, influenced no doubt by Wassily Kandinsky's theories concerning synaesthesia – the idea that one could hear images or see sounds – which were prevalent among the avant-garde. *Music, Pink and Blue No.2* is one of her earliest oils, its lush, pillowy folds such a tempting match for the gentle rise and fall of a sonata.

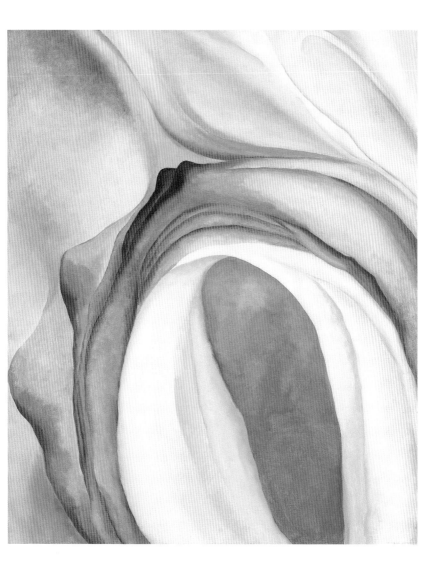

Music, Pink and Blue No. 2

Georgia O'Keeffe, 1918, oil on canvas, 88.9 × 76cm, Whitney Museum of American Art

Marlow Moss

1889-1958

A modernist to rival Mondrian

Piet Mondrian, you might think – but this sublimely balanced modernist grid is the work of British artist Marjorie Jewel 'Marlow' Moss, an influential member of the 1930s Paris avant-garde and Mondrian's lifelong friend. The two supported and challenged each other – Moss even inspired Mondrian to adopt the parallel double line. War and the clannish nature of British modernism, however, conspired to eclipse her, turning her story into a footnote to his. Much of her output was lost when her Normandy home was requisitioned and then bombed, but she ignored Mondrian's invitation to New York and fled to the remote fishing village of Lamorna in Cornwall. The area was popular with artists (alumni included Laura Knight, p.66, and Dod Procter, p.82) but Moss, a radical lesbian who favoured the clipped hair and androgynous attire of *la garçonne* (the tomboy), felt herself distinctly unwelcome. She wrote more than once to Mondrian's disciple Ben Nicholson in nearby St Ives, but was rebuffed. However solitude had its advantage, leading to a period of intense creativity. At exhibitions of her paintings in Cornwall and London, critics were impressed – even if her work was misattributed to Mondrian more than once.

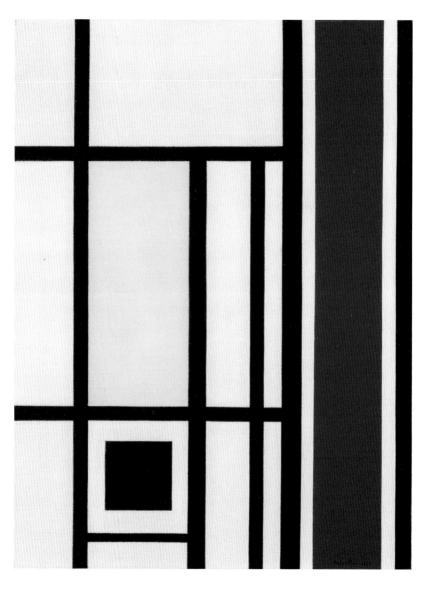

Untitled (White, Black, Blue and Yellow)

Marlow Moss, c.1954, oil on canvas, 70.7 × 55.9cm, Tate

Nina Hamnett

1890-1956

Crowned avant-garde circles in London and Paris

You know that question – who would you invite to your dream dinner party? Well, one name that should be on your list is Nina Hamnett. In her prime, the Welsh artist crowned avant-garde circles in London and Paris. She painted with Walter Sickert, drank with Modigliani, sang sea shanties with Hollywood actor Rudolph Valentino and cajoled James Joyce into a rendition of 'Daisy, Daisy, Give Me Your Answer, Do!' He thought her one of the most vital women he had ever met. Given these enviable credentials, it seems grievous that Hamnett's work isn't better known today, but there is a reason: at 66, she fell 40ft from the window of her two-room flat near Paddington Station onto the railings below. Such a violent end has, inevitably, reductively, overshadowed everything else. In fact, she drew with a lively hand and was an exceptional portraitist, as this strange and vivid painting of her landlady demonstrates. The woman's hard-edged, beady presence and her smothering, Edwardian-style interior are intensely unsettling. One can practically smell the boiled beef, hear the softly ticking clock.

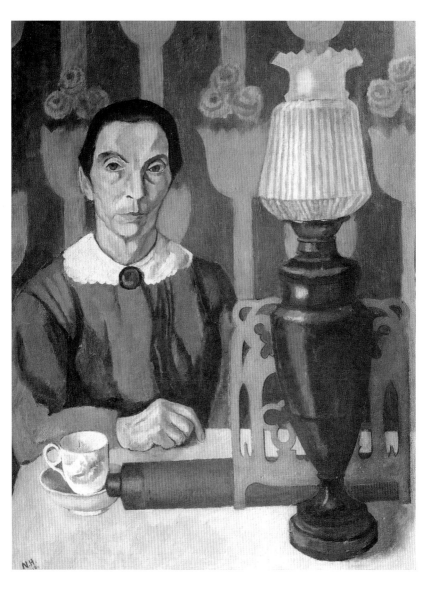

The Landlady

Nina Hamnett, 1918, oil on canvas, 88 × 55cm

Dod Procter

c.1892-1972

Wove a classical spell over British modernism

Morning met with adulation on opening day of the Royal Academy's Summer Exhibition in 1926. Hailed 'a new vision of the human figure' then voted Picture of the Year, it was bought by the *Daily Mail* for the nation and sent on a two-year tour. Procter was about the most famous woman artist in Britain after that – wined, dined and fawned over everywhere she went. A photograph of her taken that year – all Eton crop and kiss curl – suggests she was every inch the modern urbanite, but actually she'd created *Morning* in the sleepy village of Newlyn in Cornwall. Its model, 16-year-old Cissie Barnes, was the daughter of a local fish merchant. She modelled for other of Procter's paintings, too, such as *Sleeping Girl* (1927). Aside from stints in Paris (where she met Renoir and Cézanne) and in Rangoon, Burma (where she and her husband Ernest were commissioned to paint murals in the Kokine Palace), Procter lived in Newlyn nearly all her working life. The people and the surrounding countryside were ample grist to her mill, though its choicest gift was the light which she used in the manner of a fine chisel to bring the female body to glowing life.

Morning

Dod Procter, 1926, oil on canvas, 107.2 × 183.2cm, Tate

Tamara de Lempicka

1898-1980

High society portraits from the age of Art Deco

Can a single artist encapsulate an era? In the case of Tamara de Lempicka and *les années folles* ('the crazy years' of the 1920s), the answer is yes. A White Russian émigré who left Poland with Bolshevism snapping at her heels, she inveigled her way to high priestess of Paris's *demi-monde* (women on the fringes of high society), skittering among its dukes, counts and poets in a blur of gin fizz and cocaine. Painting began as a means of supporting her impoverished family. After studying in the ateliers of Maurice Denis and Andre Lhote and copying paintings in the Louvre, her talent (and some canny self-fashioning) turned her into a sought-after portraitist. It helped that she could pass for the actress Greta Garbo, but mostly people wanted her because she made them look like a prismatic, cut-glass Botticelli. In the portrait here, created for the German magazine *Die Dame*, Lempicka presents herself at the wheel of a chartreuse Bugatti – both the colour and the motor supreme status symbols of the 1920s. That Lempicka's car was really a sad yellow Renault was beside the point: 'There are no miracles,' she said, 'only what you make.'

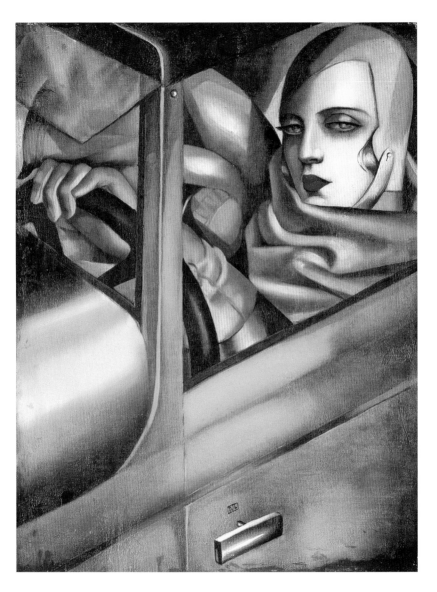

Self-Portrait (Tamara in the Green Bugatti)

Tamara de Lempicka, 1929, oil on wood, 35 × 27cm

Lotte Laserstein

1898-1993

Capturing the sparkle and swansong of the Weimar Republic

In 1937, Lotte Laserstein fled Nazi Germany for Sweden.
Though baptised Protestant, three Jewish grandparents
meant she fell foul of the Nuremberg race laws. When her
mother's apartment was confiscated, Laserstein took matters
into her own hands and organised an exhibition of her work
in Stockholm, travelled there to help install it, and never left
– though the 'rescue,' she said, 'broke my life in two'. Before,
she had been a sought-after and respected portraitist, 'one
of the very best of the young generation,' according to the
newspaper *Das Berliner Tageblatt*. Her paintings from that
time brim with a Weimar Germany that only exists in art or
myth now, so utterly was it destroyed, and of the modern
intellectuals, artists and emancipated women who made
that democratic era dazzle. *Abend über Potsdam (Evening
over Potsdam)* is about the beginning of the end, created as
ill winds first began to gust through Germany. Laserstein's
friend and model Traute Rose (seen here on the far left)
recalled that all the sitters 'had their hearts and souls in the
job because they knew that Lotte was creating a great work'.
Also that the dog eventually had to be replaced by a fur skin
because he took objection to her husband's feet.

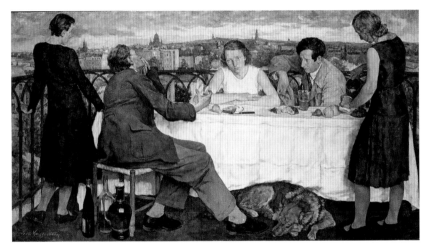

Detail from Abend über Potsdam

Lotte Laserstein, 1930, oil on board, 110×205cm

Alice Neel

1900–1984

Staunchly figurative painter of all things human

Alice Neel was an outstanding portraitist, able to convey not simply how a person looked, but what it was like to sit in the room with them, even to be in their skin. 'A collector of souls,' is how she once described herself. The soul here is her younger son, Hartley. He was 26, in his first year at medical school and 'at a low point,' he later said: tired from intensive study but conscious that military service was his only alternative – 1966, when this portrait was painted, saw the largest draft call of the Vietnam War. Lost in thought, weary in the eyes; it's all in the painting. Neel's empathy seems to have been sharpened by her own rather devastating early life. She lost her first daughter to diphtheria and the second in what would now be considered a kidnapping by the child's father, after which Neel tried to kill herself and was institutionalised. Painting played a significant role in her recovery. Pregnant women, mothers and children and, most of all, the two boys she went on to have and raise as a single mother – Richard and Hartley – were cherished subjects.

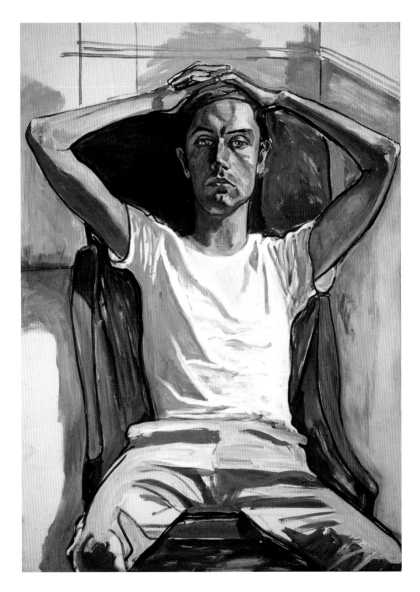

Hartley

Alice Neel, 1966, oil on canvas, 127×91.40cm

Evelyn Dunbar

1906-1960

Affectionate paintings of English horticulture

Evelyn Dunbar was a salaried Official War Artist – the only woman so appointed during World War II – and probably best known for the paintings she made of the Women's Voluntary Service and the Land Girls on England's home front. Before and after the war, however, her paintings were intently horticultural, conveying her deep-rooted affection for the English countryside, and particularly her native Kent. When she died, many hundreds of the paintings and sketches she left behind – nearly all of them unexhibited – pictured its broad horizons and ancient woods. Many of her paintings appear animated by a mystical force – personified here in the spirit of April. The painting is one of three that Dunbar worked up from a set of 12 ink drawings she had made for *Country Life* magazine's annual Gardener's Diary in 1938. They are mostly a witty, jaunty bunch – April fairly dancing towards us here, her nest hat a-twitter, an apple sapling in her hands, the essence of the season's pulse – though threaded through it are the tiniest traces of nature's unremitting cycle: the harvest and death that exist alongside birth and life.

April

Evelyn Dunbar, 1937, oil on canvas, 49×51cm

Frida Kahlo

1907-1954

*Pop culture icon who transformed
her pain into powerful art*

Frida Kahlo took up painting following a near-fatal bus acci-
dent that crushed not just her spine, leg and collarbone, but
her dream of becoming a doctor. Long, lonely stints in bed
recuperating conspired to make her chief subject her inner
life and her pain, and she scoured both as thoroughly as
Ben Nicholson did the circle, or Vermeer his house in Delft.
Thirty-odd operations and three miscarriages provided her
with plenty of material – as did her love for her adulterous
husband, fellow artist Diego Rivera. It could have been so
maudlin, but it isn't. Kahlo's grit (she tossed down tequila
'like a real mariachi,' a friend said) smoulders through her
paintings. They may be brightly coloured and folkloric but
they glint with feeling – the Surrealist André Breton put it
best when he compared her art to 'a ribbon around a bomb'.
The painting here is a tribute to two sisters who worked
as maids in Kahlo's mother's household – Salvadora and
Herminia. It's the first painting Kahlo sold, the event com-
memorated on the back with the signatures of the dinner
guests who were present. She sold relatively few in her life-
time, though her reputation has soared since. Today, her
spirited, flower-crowned face might just be the most recog-
nisable on Earth.

Dos Mujeres (Salvadora y Herminia)

Frida Kahlo, 1928, oil on canvas, 69.5 × 53.3cm, Museum of Fine Arts, Boston

Lee Krasner

1908-1984

*Trailblazing Abstract Expressionist
formerly known as Mrs Pollock*

For decades, Lee Krasner's contribution to Abstract Expressionism was overshadowed by her marriage to Jackson Pollock. The sensational timbre of his life didn't help: artistic stardom, alcoholism, infidelity, his fatal car crash. Ignored by her own generation, too old to fit in with the next – among them Helen Frankenthaler (p.108) and Joan Mitchell (p.106) – she was 75 before she had her first retrospective in 1983. Though Pollock always considered her his artistic equal, it was she who played second fiddle: when they moved into a farmhouse in Long Island, Pollock took the barn as his studio, while Krasner worked in an upstairs bedroom overlooking the creek. As if to fit her allotted space, she began small and destroyed much, but soon arrived at the larger, feathery, emotionally charged re-compositions for which she is now revered, layering torn scraps of her discarded earlier paintings with new drawings. *Vernal Yellow* is one such collage, its palette inspired by Krasner's daily habit of observing of 'a great deal of sky, the evening star at clear twilight... the colours of spring and fall,' from her back porch. It's easy to see why the critic Robert Hughes said her paintings 'rap hotly on the eyeball at 50 paces'.

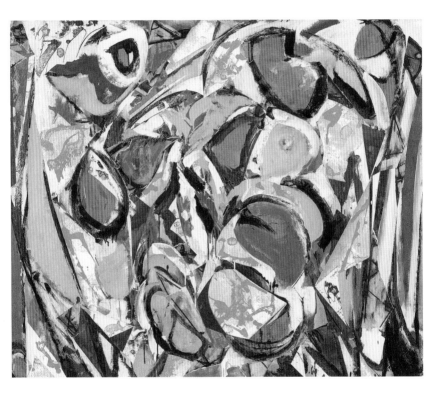

Vernal Yellow

Lee Krasner, 1980, oil collage on canvas, 149.8 × 177.8cm, Museum Ludwig

Emily Kame Kngwarreye

1910–1996

Aboriginal Australian whose spiritual
compositions won international fame

Emily Kame Kngwarreye was an Aboriginal elder and one of Australia's most important artists. She made her first painting on canvas when she was 79, drawing on her experience making works with sand and batik, along with ceremonial body painting. Over the next eight years she produced some 3,000 more, one becoming the first work by a female Australian artist – and the first Aboriginal artwork – to sell for over a million dollars. A solo show in Japan the following year broke audience records (knocking Andy Warhol from the top spot). Kngwarreye's paintings are expressions of her life as an elder of the Anmatyerre people and her custodianship of sites of women's 'Dreaming' (the English word used to describe the Australian Aboriginal cosmology). Much of the meaning of her marks is withheld from those uninitiated into the Anmatyerre ceremony, though we might discern the universal flow of energy in the glitter of her dots-within-dots, or the wanderings of the yam ancestor Yala in her tangles of interlacing lines. Perhaps even the Dreaming, which the 65,000-year-old First Nation Australian people believe is still being created, continuous and ever-present.

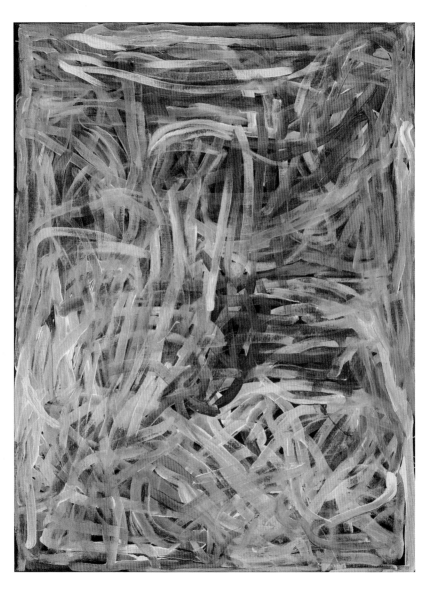

Yam Story '96

Emily Kame Kngwarreye, 1996, acrylic on canvas, 122 × 91.4cm, National Museum of Women in the Arts

Amrita Sher-Gil

1913-1941

Pioneer of modern Indian art

Amrita Sher-Gil's paintings were never going to be conventional. The daughter of a Hungarian opera singer and an Indian aristocrat, she grew up between Budapest and Choti Shimla in the foothills of the Himalayas, where her family owned a large estate. At 16, she went to Paris to study art, the city's bohemian spirit ready tinder for her wild streak (she had already been expelled from convent school for announcing herself atheist). Here, she fell hard for the work of Modigliani, Cézanne and Gauguin, but never lost herself. The choice of colours in the painting here – produced soon after she returned to India in 1934 – is informed by those artists, but the lustrous, smoky feel is hers. The models were her nieces, Beant, Narwair and Gurbhajan Kaur. Their resigned, faraway gaze and the shadows quivering on the wall behind them suggest that something is awry, unsettled. That feeling is common to Sher-Gil's paintings, which convey the reality of life for women as India approached independence. 'There are such wonderful, such glorious things in India, so many unexploited pictorial possibilities, that it is a pity that so few of us have ever attempted to look for them,' she said.

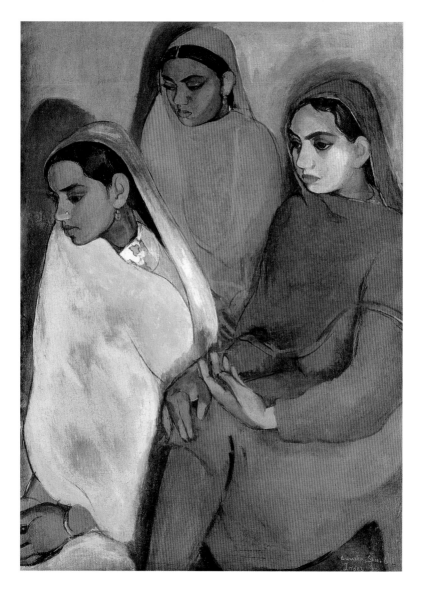

Three Girls

Amrita Sher-Gil, 1935, oil on canvas, 92.5 × 66.6cm, National Gallery of Modern Art, New Delhi

Maria Lassnig

1919-2014

Translating bodily sensations and emotions into paint

In 70 or so years of painting, Maria Lassnig was irrepressibly in motion, forever trying out, sloughing off and inventing. The tendency began early, when she shunned the social realism prescribed by Vienna's Academy of Fine Arts (then under Nazi rule) to explore the 'degenerate' style of Expressionism, followed by Cubism and Surrealism. That said, her preoccupation remained constant: what does it feel like to be human, to occupy a body? In answer, she created a new genre, *Körperbewusstsein Malerei* (body awareness painting), with which she attempted to express sensations and emotions in visual form. 'The truth resides in the feelings produced within the physical shell,' she said, and focused her enquiry on her own body: her face in cellophane, or holding a rabbit, or with a pan on her head and a telephone cord around her throat. Families were another theme, informed by her uneasy relationship with her mother (Lassnig was born out of wedlock) and stepfather, but also by the struggle she underwent in her late 30s to realise that 'a man, a child is not my destiny'. *Patriotische Familie (Patriotic Family)* dates from her Paris years, a rewarding period in which she found her freedom, and thus her unique voice.

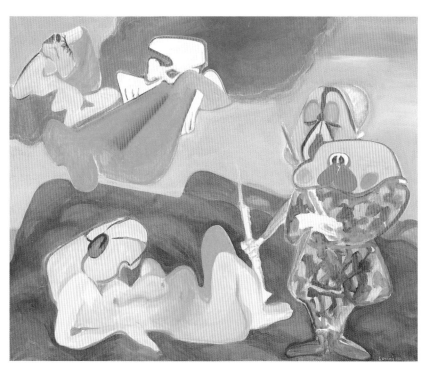

Patriotische Familie

Maria Lassnig, 1963, oil on canvas, 129 × 161.8cm, Maria Lassnig Foundation

Luchita Hurtado

1920-2020

Emphasising our connection to the cosmos

Having worked in privacy for almost half a century, painting at night when the children were asleep and turning her canvases to the wall when anyone entered her studio, Luchita Hurtado lost her artistic inhibitions on joining a collective of women artists in the 1970s. It took nearly half a century more for her to reach renown when, at 98, a huge stash of her paintings and drawings were discovered by her artist husband's studio manager. In her youth, the Venezuela-born Hurtado had been a fringe member of Mexico City's artist community, then marbled with émigré Surrealists fleeing war in Europe. She once watched muralist Diego Rivera shoot a bullet into a piñata at a children's party, and had her feet massaged by Marcel Duchamp. Surrealism later inspired her *Yo Soy (I am)* series, in which Hurtado painted what she saw looking downwards over her naked body. In them, her dramatically foreshortened form – variously walking, smoking, contemplating the world and ultimately connected to it – is abstracted into a strange, hilly landscape. 'I am part tree,' she said. 'Everything in this world, I find, I'm related to.'

Untitled

Luchita Hurtado, 1969, oil on canvas, 90.8 × 121.9cm

Françoise Gilot

1921-2023

Modernist eclipsed by the long shadow of Picasso

Let's get Picasso out of the way, because by the time Françoise Gilot painted this, he was. In 1953, after a decade as his mistress, she had set out on a new life of her own. Gilot was already a painter when they met, a pupil of the Surrealist Endre Rozsda, encouraged by Matisse and associated with a group led by Sonia Delaunay (p.74). She had painted with Picasso, too, *mano a mano* (hand to hand) at their villa in the south of France. Later, however, he saw to it that she was dropped by her Paris gallery and struck from the Salon de Mai. The lawsuits he brought against her 1964 memoir, meanwhile, led to a longstanding boycott of her work in France. Picasso hadn't counted on Gilot's resolve, though, and slowly she rebuilt her career: first in London – where the Tate gave her a studio – then the US, where she savoured the prevailing style of abstraction that Picasso had dismissed. *Dedalus* is from her 1962–64 series, inspired by the Greek myth of the Minotaur. The hulking half-man, half-bull had been a favourite theme for Picasso, but Gilot deftly expanded the tale to tell her own, embracing supporting characters such as Daedalus, architect of the beast's labyrinth, and Ariadne, whose simple string defeated it.

Dedalus (XXIX from the Labyrinth series)

Françoise Gilot, 1963, oil on canvas, 26.7×22cm

Joan Mitchell

1925-1992

Action painting inspired by the memory of landscape

To her New York School peers, Joan Mitchell was a leading young painter, admitted to the influential Artists' Club and a participant in the seminal 1951 Ninth Street Show that first presented Abstract Expressionism. And yet, as a woman in that uncomfortably macho scene, she could never quite attain top billing. By 1959, she had removed herself from this arena and settled in France, though the gestural style of painting was by then harder to shed. In her hands, though, it lost its vigorously intense, brawny quality to become something more ethereal and radiant. A single painting might take her months: 'The freedom in my work is quite controlled,' she said; 'I don't close my eyes and hope for the best.' Her home in Vétheuil, north of Paris, overlooked a small house that Monet occupied from 1878–1881, as well as a landscape he had painted. It's tempting to see the influence of that view in the blues and blazing yellows that dominate her work, though in fact she drew more on 'remembered landscapes that I carry with me – and remembered feelings of them.'

Chord II

Joan Mitchell, 1986, oil on canvas, 162×97cm, Tate

Helen Frankenthaler

1928–2011

Pioneer colourist whose paintings 'ate the art world'

Ever since Abstract Expressionism blasted onto the American art scene in the late 1940s, people began speculating about where the next breakthrough might come from. Few expected it would be a woman – let alone a 23-year-old – but in 1952, Helen Frankenthaler knelt on the floor of her New York studio, poured turpentine-thinned paint onto the canvas beneath, and created a milestone in the evolution of American art. Because she hadn't bothered to seal the surface – 'impatience, laziness,' she later admitted – the colours sank into the canvas, blooming into soft shapes that looked as if they had risen from a watery underworld. So many artists imitated her 'soak-stain' technique that the critic Robert Hughes declared the painting 'the watercolour that ate the art world', even if Frankenthaler's rapid ascension (she had a major museum exhibition before she turned 32) caused no little resentment among her cohort. Joan Mitchell (p.106) compared the paintings to sanitary towels, while Grace Hartigan said they looked as if they had been made 'between cocktails and dinner'. Frankenthaler cared not one jot: in a 60-year career, she made a point of seeking out the 'productive clumsiness,' as she called it, inherent in learning anything new: 'I would rather risk an ugly surprise,' she said, 'than rely on things I know I can do'.

Sea Level

Helen Frankenthaler, 1976, acrylic on canvas, 160 × 226cm

Eva Frankfurther

1930-1959

Chronicles of postwar London's East End

Eva Frankfurther was nine when she escaped Nazi Germany
in 1939. Her Jewish parents settled in London where, at just
16, she was accepted to the prestigious St Martin's School
of Art. From the beginning of her studies, her mind was
set: art was for the 'understanding of and commenting on
people', rather than an end in itself. She had only contempt
for 'professional tricks or gloss,' recalled fellow student Frank
Auerbach, and was 'full of feeling for people'. On graduation,
Frankfurther moved to London's East End where, inspired by
Rembrandt's etchings of Amsterdam's Jewish population and
Käthe Kollwitz's drawings of workers, she sought to immor-
talise Whitechapel's largely settler population of orphans,
rabbis, sex workers, street musicians and dockers. To make
ends meet she worked at a Lyons Corner House, a prestig-
ious London teashop. The West Indian waitresses shown
here, in the white cap of a Lyons' 'Nippy', were perhaps her
colleagues. But moving in a world of poverty and insecurity
wasn't without blowback. Aged 28 and in the grip of depres-
sion, Frankfurther took her own life.

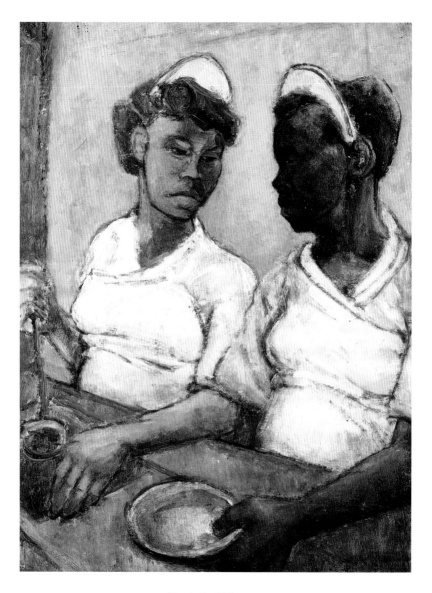

West Indian Waitresses

Eva Frankfurther, c.1955, oil on paper, 76 × 55cm, Ben Uri Gallery and Museum

Bridget Riley

b.1931

Op Art maestro whose patterns made the sixties swing

Bridget Riley is the grand dame of Op Art. Many of its hallucinatory geometric patterns were her invention. Her knack for line and shape, shift and shimmer, famously leave her more constitutionally delicate viewers motion-sick and dizzy. An early passion for the paintings of the 19th-century pointillist Georges Seurat – who broke down what he saw into distinct dots of colour that our eyes automatically reassemble – set Riley on her path. His paintings were figurative, but Riley preferred the basic elements of form: 'the line, the rectangle, the plane. I found that when I distorted them they became active,' she said. Op Art – it's short for optical art – first flourished in the late 1950s and 1960s, when it was as ubiquitous as Twiggy and The Beatles. Riley's early works, with which she quickly established her stellar reputation, were in eyeball-smacking black and white, though today she mostly works in colour. *Entice I* is an outstanding example. Such pristine geometrical elegance, yet your eyes persist in bouncing and leaping about the picture, trying to make sense of what they see.

Entice I

Bridget Riley, 1974, acrylic on linen, 124.5 × 101.6cm

Paula Rego

1935–2022

Uncompromising storyteller of imaginative power

Pipe in mouth, an artist presides over her studio. The conflicting scales of the objects and her real-life and plaster entourage is complex; the room less a workspace than a set where fairytale worlds are brought to life. There's even a shadow theatre on the rear wall. Rego made the painting following a residency at the National Gallery during which she re-cast a number of paintings in its 'masculine collection' – her words – with women, telling familiar stories and myths from feminine perspectives. Fables, folktales and classic literature streak much of her work, always undermined in some mischievous or lacerating way. Once seen, they change your view of the original utterly, though that seems to be her aim: 'I always want to turn things on their heads,' she has said, 'to upset the established order.' Accordingly, *The Artist in Her Studio* 'upsets' the many grandiose self-portraits in museums the world over, though the sitter is not Rego but her assistant, Lila Nunes, and the figure 'a type of George Sand character,' the artist explained. Sand, a Romantic-era French novelist, was well-known for her pipe-smoking, wearing men's attire (illegal in 1800s Paris) and, rather like Rego, for not giving a damn.

The Artist in her Studio

Paula Rego, 1993, acrylic on canvas, 180×130cm, Leeds Art Gallery

Mary Heilmann

b.1940

Playful minimalism by way of California

Just a few years after minimalist artist Donald Judd proclaimed the death of painting in 1965, Mary Heilmann decided to take it up. As a West Coaster and a woman, she was finding it hard to crack New York's male-dominated art scene, and telling people she was a painter seemed a sure-fire strategy. By being 'just plain provocative with the fellas,' she said, she could draw them into 'a conversation, a beef. I don't think people fight like that any more, but then it was part of the deal.' Heilmann quickly forged her own idiom: where Judd acolytes pursued immaculate surface and sharp geometry, Heilmann was unrepentantly playful, making a virtue of the sweetly wonky, unaffected application of paint. That's not to say her art isn't serious: its blobs, splotches and oblongs enlarge on modernist grids, Cubist geometry and the drips of Abstract Expressionism. She credits David Hockney (whose seminar she snuck into while studying sculpture at Berkeley) with teaching her not to take herself too seriously, though the airy, exuberant quality of her paintings is all her own: the product, perhaps of her California roots.

First three for two red, yellow, blue

Mary Heilmann, 1975, oil on canvas, 145.4×89.5cm

Pat Steir

b.1940

Conceptual artist inspired by chance and chaos

Pat Steir is a leading figure of contemporary Conceptual Abstraction, who rose to prominence in 1970s New York with the first generation of feminist artists. She is best known for her *Waterfall* paintings, large-scale pieces made by dripping, drizzling and flinging paint from a saturated brush, then letting gravity, time and – as she describes it – 'the will of nature' guide the cascade. The technique is influenced by the chaos theories of her friend the composer John Cage, eastern philosophies such as Taoism and ancient Chinese painting. Indeed, she created the first following a visit to Guilin, Beijing and Shanghai in the 1980s, during which she encountered Chinese *Yi-pin* (ink-splashing paintings) from the eighth and ninth centuries. *Considering Rothko* is one of a series in which Steir examines her connection to the work of the Abstract Expressionist Mark Rothko, whom she met at a dinner party in Cape Cod when she was in her 20s: 'I said, "Mr. Rothko, I love your work!" And he said, "You're a pretty girl. Why aren't you married?" He didn't even register that I was an artist and loved his work… I was disappointed. I was hoping to discuss colour theory with him.'

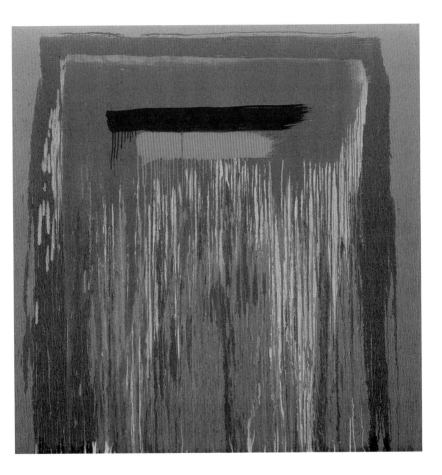

Considering Rothko #10

Pat Steir, 2020-2021, oil on canvas, 121.9 × 121.9cm

Maggi Hambling

b.1945

Matters of life and death

Maggi Hambling learned to paint at the freewheeling Benton End art school in Suffolk – Lucian Freud was a fellow alumnus – and came up through the Slade, where she socialised with Bridget Riley (p.112), David Hockney and Derek Jarman, along with the rackety Soho set. Her body of work can appear miscellaneous at first, but is united in its consideration of life's vital animating force. She has made portraits of the elderly, dying or recently dead (sometimes on deathbeds or in coffins) and of anonymous war victims, though her true muse might be the sea, whose blustery, booming drama – water and the wind ceaselessly duking it out – she paints every morning. In 1980, during her residency at the National Gallery, she made a study of the figure of a sergeant in Edouard Manet's 1868 masterpiece, *The Execution of Maximilian*. Set apart from the rest of his squad, forever loading his gun for the coup de grâce, his ghost haunts the woman here, her finger crabbed over the trigger of a rocket launcher. Manet based his work on a newspaper report; Hambling hers on a photograph in *The Times* showing preparations for the Iran-Iraq war, though whose side the women are fighting for is purposely left unclear.

Gulf Women Prepare for War

Maggi Hambling, 1986, oil on canvas, 122×145cm, The Women's Art Collection

Lubaina Himid

b.1954

Giving voice to the silenced

Lubaina Himid sifts history for gaps, giving a voice and a name to those who have been overlooked, silenced or worse on account of their race, gender or class. Her paintings recover and reconsider those events, heaving them back into view. Consider this painting from her series *Le Rodeur*, titled for a French slave ship that in 1819, en route to the Caribbean, suffered an outbreak of ophthalmia, which left 162 enslaved people blind. Given a blind slave was unsellable, the captain threw those he thought permanently affected overboard, their legs weighted. The atrocity was recorded in a medical journal, though not one of the 36 victims was named. Himid sets the story inside six stage set-like boxes, which makes the events feel as if they are happening in front of us (and we voyeurs, perhaps even complicit). Each scene is light-bleached yet drenched with menace. The ocean appears in all six – a terrible portent. Despite its simplicity, the painting is knitted together in a way that doesn't quite make sense. Himid sought to convey 'that feeling of confusion, of not knowing exactly what is going on... the "ghost" of it all, the shudder in the room.'

Le Rodeur: The Exchange

Lubaina Himid, 2016, acrylic on canvas, 184×244cm

Beatriz Milhazes

b.1960

Bringing Brazilian verve to European modernism

A Beatriz Milhazes painting makes immensely pleasurable viewing: a swoosh of colour and pattern, strong and energetic. Her large-scale abstractions are meant to suggest 'living in Rio... the swing... the atmosphere,' she has said, and it's true. The crisp shapes and bright hues conjure the Brazilian colonial architecture and tropical foliage – her studio overlooks Rio's botanical gardens and the Tijuca rainforest – along with its pop culture and heritage: the art and music of the 1960s Tropicália movement, carnival, the sophisticated rhythms of Bossa Nova. Milhazes is part of Brazil's *Geração 80* (1980s Generation), a group of artists whose exuberant works were inspired by the ousting of Brazil's oppressive military regime. She paints onto transparent plastic that she then sticks to the canvas and peels off to leave a smooth and bold film of paint, which gives a very painterly result. It's partly inspired by Matisse's late cut-outs, but you'll also see licks of Sonia Delaunay (p.74), Hilma af Klint (p.52) and Bridget Riley (p.112) in Milhazes's style. Her great skill is to hold these multiple influences, eras, continents and languages in play at once. 'It's very controlled, every single thing, every piece has a reason,' she has said. 'It's like a mathematical dream.'

Roda Coração III

Beatriz Milhazes, 2021, acrylic on linen 193.7×200.3cm

Tracey Emin

b.1963

Exposing body and soul to explore love, loss and grief

Except for its pronoun, the Renaissance proverb 'every painter paints himself' might have been penned expressly with Tracey Emin in mind. The Margate-bred *femme terrible* of the Young British Artists readily mines her own body and inner life for subject matter, and commonly in the most provocative way possible. Still best known for exhibiting her unmade bed, Emin's paintings take a less lapel-clutching (though equally heart-on-sleeve) approach, fusing love, sex and yearning with a slavish return to historic traumas: an abortion, a rape, parental death. The example here is one of a sequence she made in the late 2010s, in which wraithlike nudes – the ghostly heirs of Manet, Titian and Courbet – recline and writhe behind jagged rivulets and clots, not quite tangible enough to invite objectification. Emin's marks are loose and febrile, working urgently to pinion the flit of feelings. The paintings blaze with emotion, proof positive of Emin's ability to stun her audience.

It was all too Much

Tracey Emin, 2018, acrylic on canvas, 182.3×182.3cm

Nicole Eisenman

b.1965

Holding a mirror to the political moment

No one captures the human predicament, the holy mess of the way we live now, better than Nicole Eisenman. Her critical yet witty paintings grapple with race, the social consequences of technology, guns and gender, as well as loneliness and fear. She is also a great painter, each canvas an apparition of strange colours and styles, fantasy and reality, banality and transcendence. You're as likely to spy the grim reaper or a minotaur as a doom-scrolling teen and red solo cups. *The Triumph of Poverty* is a response to the 2007-2009 US financial crisis. Somewhere in its ancestry are the photographs of the Great Depression commissioned by the US government, though the title has British roots: from a lost Holbein painting that once ornamented the London headquarters of a powerful confederation of merchants. Eisenman swaps Holbein's carriage for the rusting wreck of a car, its naked driver a veiny-nosed sot. Attached to the gang's dishevelled leader are six figures from a 1568 painting by Bruegel the Elder, *The Blind Leading the Blind*. None of us know where industry or technology is taking us, says Eisenman. That she can convert this hellish idea into a work that is elegant and entertaining makes her something like an aesthetic philosopher, and a genius.

The Triumph of Poverty

Nicole Eisenman, 2009, oil on canvas, 165.1 × 208.3cm

Cecily Brown

b.1969

Vanitas for the 21st century

Fixed meanings make Cecily Brown nervous. In consequence, her paintings are in unrelenting flux, an impenetrable havoc of foaming, fevered brushstrokes. Not a centimetre of the canvas is spared. Fundamental to their effect is the way she interrupts the routine exchange of information between eye and brain: we half-see objects but fragmented or mid-metamorphosis. 'What I really want is for people to stop and look as hard as possible,' Brown has said. 'It is all about ambiguity, and keeping things up in the air. In the end it does not matter that much what it is of, you will bring your own story to it.' The example here is (perhaps) a summer landscape – we certainly sense that season's pulse and hum, its blue sky and temperate air – but spend some time with the maelstrom of marks and two squirming bodies materialise in the bucolic scene. Couplings like these haunt her early paintings, not least the speed-breeding rabbits that made her famous in late 1990s New York, though nowadays 17th-century vanitas (still lifes that that suggest worldly vanity or life's brevity) are more her bag, her paintings strewn with rot and opulence in a nightmarish rendering for the contemporary age.

Figure in a Landscape

Cecily Brown, 2002, oil on linen, 203.2 × 203.2cm

Shahzia Sikander

b.1969

Remaking miniatures for the modern age

Shahzia Sikander is a pioneer of neo-miniature, expanding
and subverting the age-old conventions of Central and South
Asian miniature painting to respond to present-day issues.
Now based in New York, she learned its exacting techniques
(staining paper; extracting hair from a squirrel's tail, etc.)
at the National College of Arts in Lahore in the late 1980s.
Her teacher, master miniaturist Bashir Ahmed, had been the
pupil of a former Mughal court artist. Traditionally, min-
iatures were made by men and about men, depicting court
life and God's creation. Sikander's interpretations adopt the
same vocabulary (decorative borders, architectural settings, a
story unfolding over time, and so on) for very different ends:
interrogating power imbalances, racial narratives, colonial his-
tories and migration – and through a feminist perspective. In
The Explosion of the Company Man, her target is the East
India Company, the trading monopoly that was Britain's tool
of colonial expansion in India and beyond. The 'Company
Man' here stands for the repercussions of colonialism and
the Opium Wars – and in Sikander's world, he is toast.

The Explosion of the Company Man

Shahzia Sikander, 2011, gouache, hand painting,
gold leaf and silkscreened pigment on paper, 159.4 × 190.5cm

Chantal Joffe

b.1969

Emotion-steeped portraits of transitional moments

Chantal Joffe's paintings of herself and her daughter, Esme, feel about as keenly real and as drenched with emotion as portraits get. They insinuate the act of care and being cared for in return and, cumulatively, time's passage – the shift between mother and daughter as a teenaged Esme journeys away from her. But we're ahead of ourselves: in this painting, she is only five, still firmly in the crook of her mother's body, their conjoined forms all but filling the frame in an array of beautiful buttermilks and pinks. There is so much feeling embedded in, and radiating from, their togetherness. Few artists come close in painting human feeling. Though she used to paint from 'found' images, these days it's more usual for Joffe to work from life, or from drawings, or her own photographs. The paintings are never a straight copy, however, since she abbreviates, augments and omits as needed. 'I think the heavier the emotion, the more abstract way I use the paint,' she has said. The squinching and stretching of form and scale keep both the reality of paint and process and the reality of her subject equally before the viewer – the end result is more vital than a photograph could ever be.

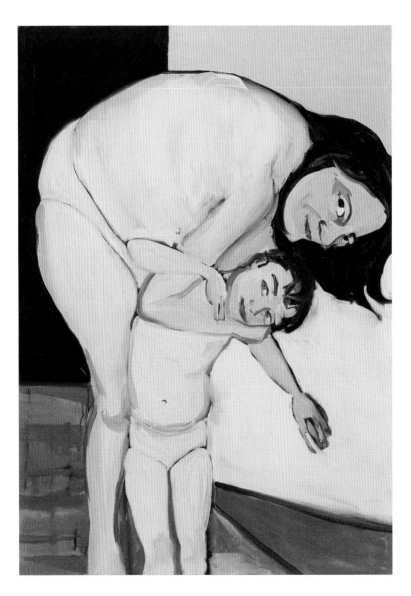

Self-Portrait with Esme

Chantal Joffe, 2009, oil on linen, 213.5×152.5cm

Julie Mehretu

b.1970

Multi-layered mappings of modern realities

Look closely at this painting. Beneath its calligraphic dashes and coloured shapes lie the bones of a city. Not a real one; more a radical imagining, though still precise. A whirl of landscape and architecture in multiple and conflicting perspectives. In this instance, its tangled, explosive form conveys the 'supreme dazzling capacity' of places like Lagos or Times Square, Mehretu has said, but that gives only a hint of her reach. For each painting, Mehretu, who was born in Addis Ababa and lives in New York, assembles an archive – of maps, architectural plans, clippings from newspapers and magazines and more – drawing as easily on Babylonian carved stone slabs as the 19th-century painting *The Raft of the Medusa* by Théodore Géricault. These form a structure (or a cosmos) onto which Mehretu can layer her responses to our current reality. Churning away in her canvases are war, protest, migration, colonialism, capitalism, Brexit anti-immigration rallies, Hurricane Sandy, California wildfires, the burning of Rohingya villages in Myanmar. 'My aim is to have pictures that appear one way from a distance,' she has said, 'but then when you approach the work, the overall image shatters into numerous other pictures, stories and events.'

UNTITLED 2

Julie Mehretu, 1999, ink and polymer on canvas mounted to board, 151.8 × 182.2cm

Amy Sherald

b.1973

Mythical beings challenge the narrative

Yellow and blue are a potent pair, as Vermeer and Van Gogh well knew. *Saint Woman*'s is that alliance, and then some: its ground is a molten, prismatic gold – the shade you'd ordinarily see on a medieval altarpiece or manuscript, and that's the point. Drawing on (while also chiselling away at) the traditions of Western art, Amy Sherald brings, in her words, 'a kind of poetry' to 'Black people just being themselves... I am looking for versions of myself in art history and in the world.' *Saint Woman* is an everywoman, though not a stereotype. Her breeze-blown dress even mimics the age-old Hollywood cliché that signifies a hero or someone at the mercy of fate. Sherald, who grew up in the American South, identifies her early years negotiating race and identity as a major influence. Her paintings begin with a photograph of an individual who interests her – a friend of a friend, perhaps, or a person on the subway. 'I just see people and know,' she has said. Some she decorates with props or a costume – a fish, a fur-collared coat, a sash and tiara – but all are given *grisaille* (grey toned) skin, a hue outside the ordinary categorisation of race that also turns Sherald's models from ordinary humans to mythical beings, beyond the dominant narrative of history.

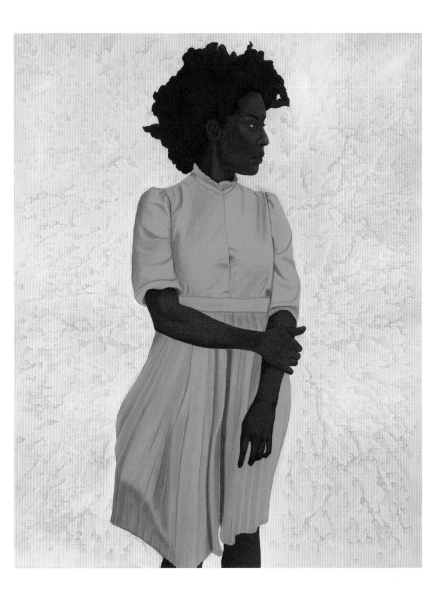

Saint Woman

Amy Sherald, 2015, oil on canvas, 137.2 × 109.2cm

Chen Ke

b.1978

Honouring the women of the Bauhaus

Chen Ke's series *Bauhaus Gal* began with a book of black-and-white photographs of young female students from the Bauhaus, the groundbreaking school of art and design founded in Germany in 1919 by architect Walter Gropius. The school touted equality between the sexes – when it opened, more women applied than men – but those lofty aims turned to empty rhetoric: women 'Bauhauslers' found themselves consigned to handweaving and photography, fighting for recognition and, all too soon, facing Nazi repression. Looking at the photographs, Chen has said, was like travelling through time: the confidence and courage required of the girls in a setting that associated genius with masculinity was reminiscent of her own experience as an art student and subsequently as a female artist on the Beijing scene of the early 2000s. The Bauhaus paintings are not exact copies of the photographs, but reimagined in chiselled classical style and glowing acid colours. The weight of what's coming weaves another layer of suspense into the painting, though the women, with their cropped hair and artful clothes, are blissfully unaware.

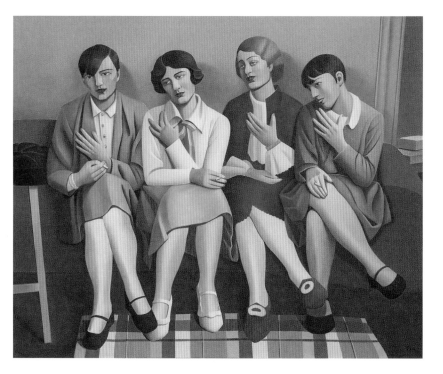

Bauhaus Gal No.12

Chen Ke, 2021, oil on canvas, 200 × 250cm

Thenjiwe Niki Nkosi

b.1980

Exploring power, identity and representation

In a cat's cradle of fibreglass and steel, girl gymnasts prepare to compete on the uneven bars. They're still earthbound for the moment, in fluttery anticipation. This painting belongs to Johannesburg-based Nkosi's series *Gymnasium*, and envisions an arena – and implicitly, a world – in which Black bodies (and that includes the onlookers, judges and cameramen, as much as the gymnasts) are ordinary rather than anomalous. 'Gymnastics has been used as a tool of propaganda, of control, of patriarchy and of nationalism,' Nkosi has explained. 'Defining what bodies should look like, what perfection is, what the ideal human is.' She found pertinence in the story of Simone Biles, a Black gymnast who became the most decorated American gymnast of all time in 2019, competing in the traditionally white elite sport. Nkosi was navigating a fiercely competitive arena of her own: the still largely white-dominated art world. 'The artist, like the gymnast, is witnessed and judged,' she has said. 'What inner resources allow a person to emerge – walk through, walk away – from such glaring scrutiny not only with their humanity intact, but with grace?'

Trials

Thenjiwe Niki Nkosi, 2020, oil on Belgian linen, 100×150cm

Njideka Akunyili Crosby

b.1983

Giving visual form to the nuances of postcolonial identity

Njideka Akunyili Crosby describes her pictures of interiors as 'portals', which is about right. Each is an intricate mash-up of painting, drawing and collage, of prints from African magazines and family photo albums, of materials like marble, steel and glass, crushed and swirled into paint. The scenarios are familiar, redolent of home; the characters configured to suggest an easy intimacy. The artist's alter ego appears and reappears, moving between canvases as Akunyili Crosby, a Nigerian-born artist who lives in LA, has moved between continents. Indeed, everything here – each piece of furniture, every book, biscuit, beer can, floor tile and plant – represents the texture of her dual identity. 'Objects have this specificity that tell stories of place and time,' she has explained. The mash-up, then, is a metaphor for the intricate merging of cultural backgrounds that contributes to (and sometimes troubles) an immigrant's sense of self. For Akunyili Crosby, it's the former, her paintings a way to resist the idea that, 'to become American is to assimilate… to reject or deny what you bring with you,' she has said. 'I'm saying, no… You can hang on to those things you bring with you. I'm Nigerian, I'm American — you can be both.'

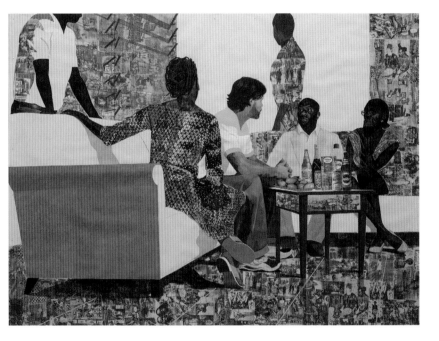

Something Split and New

Njideka Akunyili Crosby, 2013, acrylic, transfers, coloured pencil, pastel,
charcoal, marble dust and collage on paper, 213.4×281.9cm

Hulda Guzmán

b.1984

Magical realism in pristinely constructed environments

Hulda Guzmán paints paradisiacal landscapes and chic modernist interiors, all in a blazing flash of pure colour. This one pictures her studio in the remote mountains of Samaná, Dominican Republic. It was designed by her architect father and oh, *those windows*. The painting is a *mise en abyme* – a painting within a painting, endlessly repeating. Quite an effect, isn't it? And yet the revelation of the picture is really its detail and its little surprises: the stretched-out cat, the starchy pot plants and statement furniture, the sodium-orange glow of lamplight rouging the underside of the leaves outside. What strangeness is unfolding here? Guzmán sometimes seasons her paintings with fantastical creatures too – dancing cockerels, a pipe-playing cat, even a gaggle of tiny red devils, intent on mayhem. They are each inspired by medieval bestiary and have led to comparisons with the 'naive' painter Henri Rousseau, whose pictures of imaginary jungles inspire Guzmán, as do the colourful, dynamic scenes depicted in *ukiyo-e* (Japanese woodblock prints) and Pointillism (dots sometimes replace her figures' edges). She sets those diverse ancestors, and her shifting, magical realist-cast, into pristinely constructed environments. Each crackles with a sense of supernatural possibility.

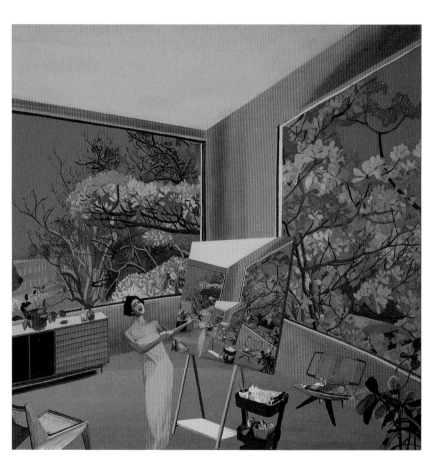

pintando la almendra

Hulda Guzmán, 2020, acrylic gouache on linen, 114.3 × 114.3cm

Flora Yukhnovich

b.1990

Reimagining the Rococo through the lens of abstraction

Viewing a Flora Yukhnovich painting is a bit like looking through dappled glass, where the scene beyond acquires a half-dissolved quality, the colours wobbling and blooming into soft impressions. Their soft pastel tones and lilting feel come from Rococo – a playful, cake-like movement associated with 18th-century France and the painters François Boucher and Jean-Honoré Fragonard. Pleasure and romance were their principal themes in paintings directed at the senses rather than the intellect. 'In many ways, it's revved-up silliness,' Yukhnovich has said. 'But I think there's a seriousness there. A seriousness to do with the female form and the male gaze.' When you look at it this way, the artist's abstractionist technique might have another, more sly goal in mind: the blurring of bodies a means of obstructing objectification. All those sweeps and swirls also draw our attention to the paint itself – the claggy stuff of it and its gestural, vital application. It is difficult not to think of the Abstract Expressionists, and Yukhnovich has said she often does. Given the macho way in which that period has been framed, it's tempting to see her less muscular, more pillowy and eminently witty approach as a reclaiming.

Fantasia

Flora Yukhnovich, 2019, oil on linen, 150×170cm

Where to find out more

Books and essays

The Story of Art Without Men
by Katy Hessel
A revisionist look at the history of art through the work of women artists.

'Why Have There Been No Great Women Artists?' by Linda Nochlin
A seminal piece of feminist art theory, this 1971 essay examined the social and institutional obstacles that prevented women from succeeding in the art world.

How Not to Exclude Artist Mothers
by Hettie Judah
A polemical argument for how the art world can, and must, change to account for the needs of artist parents.

Great Women Artists and *Great Women Painters*, both by Phaidon
Enormous tomes profiling hundreds of women artists from all over the world and spanning five centuries of history.

Forgotten Women: The Artists
by Zing Tsjeng
A people-focused alternative art history offering stories of 48 women whose influence in art has been overlooked.

Ninth Street Women by Mary Gabriel
A closer look at five women and Abstract Expressionist painters – Lee Krasner, Elaine de Kooning, Grace Hartigan, Joan Mitchell and Helen Frankenthaler – who disrupted the male-dominated art world of postwar America.

This Dark Country
by Rebecca Birrell
A group biography of early 20th-century women artists as told through their still life paintings.

The Mirror and the Palette
by Jennifer Higgie
A radical and revisionist exploration of 500 years of women's self-portraiture.

Guerrilla Girls: The Art of Behaving Badly by the Guerrilla Girls
The first book to catalogue the pioneering work of feminist activist group the Guerrilla Girls, who have been challenging gender-based discrimination in art since 1985.

Podcasts

The Great Women Artists
Art historian Katy Hessel interviews contemporary female artists on their career or other art world figures on the female artist who means the most to them.

Bow Down: Women in Art
Short episodes hosted by Jennifer Higgie, *Frieze* editor-at-large, in which an artist, writer, historian or curator speaks about a woman artist to whom we should bow down.

The Art History Babes
A chatty, accessible approach to art history and theory, including episodes on erotic art, kitsch and social media as well as interviews with artists and episodes dedicated to famous artworks.

Museums and collections

The Women's Art Collection, Murray Edwards College
Europe's largest collection of art by women, including over 600 works by leading modern and contemporary artists such as Paula Rego, Lubaina Himid and Tracey Emin, plus talks, tours and workshops.
Cambridge, UK, womensart. murrayedwards.cam.ac.uk

Femmes Artistes du Musée de Mougins
Formerly the Mougins Museum of Classical Art, art collector Charles Levett's refurbished FAMM reopens in June 2024 with a new name and new focus, becoming the first museum in Europe dedicated solely to women artists.
Mougins, France, famm.art

National Museum of Women in the Arts
The world's first museum dedicated solely to showcasing women artists and advocating for women in the arts. Their website offers educational resources and opportunities to get involved in advocacy campaigns.
Washington DC, USA, nmwa.org.

The Elizabeth A. Sackler Center for Feminist Art, Brooklyn Museum
A collection and educational facility championing feminist art. Includes The Feminist Art Base, a free-to-access digital archive of feminist art from the 1960s to the early 2000s.
New York, USA, brooklynmuseum. org/eascfa

Baltimore Museum of Art
Embodying a principle of social equity through its collections as well as its staffing, the BMA is dedicated to promoting women artists via exhibitions focused on overlooked artists from Baltimore and beyond.
Baltimore, USA, artbma.org

Linda Lee Alter Collection, PAFA
Art collector and artist Linda Lee Alter collected over 500 works by women artists (including Alice Neel, Faith Ringgold and Kara Walker), now housed at the PAFA, where many of the works are on permanent display. The collection is fully digitalised and accessible for free online.
Pennsylvania, USA, pafa.org/museum/ collection/linda-lee-alter-collection

Glossary

Abstraction
A style in which an artist focuses on colour and shape, with little or no reference to external visual reality. The work tends to communicate a feeling or an idea and order and simplicity are key. It emerged in Europe in the early 20th century and has remained a dominant part of modern art ever since.

Action painting
See *Gestural Abstraction*.

Art Deco
A style that flared into being at the 1925 International Exhibition of Modern Decorative and Industrial Arts in Paris, and quickly spread across the world. It was allied with pleasure and leisure: a means of signalling modernity, comfort, efficiency and luxury.

Avant-garde
A French term that translates as 'advance guard', it stems from the belief that art could help bring about a new society. Nowadays, it's used to describe any radical artwork that explores new forms or ideas.

Baroque
A dynamic and ornate style that emerged in the 17th century, characterised by dramatic compositions, exaggerated motion and elaborate details. Meant to provoke awe and often associated with the Catholic Church, its paintings tend to feature intense emotions and contrasts of light and shadow (*chiaroscuro*).

Bauhaus
The Bauhaus School of Art and Design was a revolutionary design school founded in 1919 in Germany by architect Walter Gropius. It aimed to integrate craftsmanship with modern technology, emphasising functional, minimalist design. The Bauhaus influenced various artistic disciplines, promoting a synthesis of art, craftsmanship and industrial production.

Belle-Epoque
Meaning 'beautiful era', a period of French history beginning in the 1870s and ending with WWI characterised by peace, prosperity and scientific and cultural innovation, during which the arts flourished.

Bijin-ga
A genre of Japanese art that focuses on depicting beautiful women. Originating in the Edo period (17th to 19th centuries), its paintings showcase elegant and idealised women, reflecting cultural standards of beauty and elegance. *Bijin-ga* is associated with *ukiyo-e*, woodblock prints that gained popularity during the same period.

Bloomsbury Group
Collective of avant-garde English writers and artists active in the Bloomsbury area of London in the early 20th century. Rejecting the stifling societal and artistic norms of the Victorian era, they embraced modernist ideas and encouraged creative freedom.

Body awareness painting
Focuses on the relationship between the artist

and their body as well as the wider world, exploring themes of body image, the human form and cultural perspectives.

Classicism

A style that makes reference to the arts and culture of the ancient civilisations of Greece and Rome. Its characteristics of harmony, proportion and idealised forms and its mythology have had a profound influence on Western art.

Composition

The arrangement of figurative or abstract elements in a painting to create a sense of harmony or balance. Artists have historically used geometry to create ideal compositions.

Conceptual Abstraction

A form of artistic expression in which the emphasis is on conveying abstract or complex ideas rather than representing tangible objects or realistic forms, thus fostering an intellectual engagement with the artwork.

Cubism

A radical new approach to representing reality invented by artists Pablo Picasso and Georges Braque. It began in Paris around 1907–08 and is characterised by fragmented compositions in which multiple views of a subject are presented together in the same picture.

Dutch Golden Age

Era roughly spanning 1588 to 1672 in which the Dutch Republic emerged as Europe's most prosperous and powerful nation, and Dutch culture and military power were the most acclaimed in the world. Associated with artists such as Rembrandt van Rijn and Johannes Vermeer, who produced some of the most celebrated portraits, still life and genre (everyday scenes) paintings in art history.

École des Beaux-Arts

Prestigious French art school that emerged from the teaching Académie Royale de Peinture et de Sculpture, established in Paris in 1648. Renowned for its adherence to the Classical tradition, and traditional, highly structured approach, it had become renowned for conservatism by the late 19th century.

Expressionism

Movement that emerged in Germany as a response to the prevailing naturalistic style of the late 19th century. It aimed to convey strong emotion through bold colour and distorted forms, and focused on social and political themes as much as personal emotional experience.

Figurative

A term used to describe the work of artists whose work, although not realist, draws on figures and objects from the real world – unlike abstract art.

Foreshortening

Technique that creates the illusion of an object or figure receding into space.

Futurism

Movement devoted to the speed and energy of the modern world. Founded by the Italian poet Filippo Tommaso Marinetti in 1909, when

he published his *Manifesto of Futurism* on the front page of the Paris newspaper *Le Figaro*.

Genre
From the French word 'kind' or 'type', paintings that focus on ordinary people and everyday settings. It became popular in the Netherlands in the 17th century.

Gestural Abstraction
A style associated with expressive brushwork and spontaneous mark making. Also referred to as 'action painting' to describe the dynamic, physical way in which the work is created, where paint is randomly splashed, dripped or poured onto the canvas rather than being applied with precision.

History painting
Paintings that draw on Ancient Greek and Roman mythology and the Bible for their subject matter. The term was introduced by the French Royal Academy in the 17th century when history paintings were considered superior to any other genre.

Illuminated manuscripts
The decoration of handwritten medieval and Renaissance manuscripts with elaborate illustrations and embellishments in gold, silver and rich colours.

Impressionism
A style of painting developed in France during the mid-to-late 19th century characterised by loose brushwork, unblended colour, light and atmosphere. The term 'Impressionism' came from a satirical review by the French art critic Louis Leroy of the group's first exhibition in 1874.

Magical realism
Mixes realistic depictions of the world with surreal or magical elements, creating a dreamlike atmosphere and inviting the viewer to question the boundaries between fantasy and reality.

Miniaturist
Artist who produces small-scale, incredibly detailed paintings requiring precise craftsmanship. The name is

derived from the minium (or red lead) used by medieval illuminators. The genre was popularised by the Tudors and waned in the 19th century.

Mise en abyme
French term that refers to a painting within a painting, where a smaller copy of itself is placed within a work.

Modern art
Distinct from the broader movement 'modernism', modern art describes art made during the late 19th century and early 20th century, characterised by a rejection of traditional forms and techniques. In particular, the focus was on personal expression and interpretation rather than realistic depiction.

Modernism
Broad philosophical movement that began in the late 19th century and reached its pinnacle in the mid-20th century. Emerging in response to the developments brought by industralisation and globalisation,

it sought new ways to reflect the changing world.

Neoclassical
Movement that emerged in the mid-18th century and peaked in the early 19th century and which drew inspiration from ancient Greek and Roman culture.

New York School
Group of avant-garde artists in New York City who were active after World War II until the 1960s, chiefly associated with the development of Abstract Expressionism.

Old Master
A pre-eminent painter of great skill working in Europe between the 13th and 18th centuries, such as Hans Holbein and Anthony van Dyck.

Op Art
A style of abstract art developed in the 1960s in which geometrical patterns and colour contrast to create optical illusions that often result in canvases that look, to the human eye, as if they're flickering.

Perspective
The representation of three-dimensional objects within two-dimensional artworks. It requires the artist to use various techniques to create an illusion of space and depth on the canvas.

En plein air
The act of painting outside, in the open air, away from the studio or classroom so as to better capture shifting patterns of light and weather. Pioneered by John Constable in Britain, but largely popularised by later French Impressionists.

Pointillism
Style that emerged in late 19th-century France, where small dots of colour are placed so that from a distance they form a shimmering, recognisable composition.

Post-Impressionism
Late 19th-century movement that expanded on Impressionist ideas around capturing light and atmosphere, but emphasised personal interpretation and the expressive use of colour and form.

Primitivism
The appreciation and imitation of styles perceived to be 'primitive' or from an earlier stage of human development. Primitivist art may adopt a naive approach and use simplistic forms and colours.

Realism
A movement of the 19th century that rejected romantic and idealised portrayals of the world in favour of accurate representation, everyday subjects and social commentary.

Renaissance art
A great cultural revival that began in 15th-century Florence inspired by the art and literature of ancient Greece and Rome. Renaissance art reached Britain in the middle of the 16th century.

Rococo
A playful movement associated with 18th-century France that favoured ornamentation, pastel colours and

delicate forms, evoking a romantic and frivolous spirit.

Royal Academy of Arts
Founded in 1768 by a group of 40 artists and architects, the RA is a prestigious art institution in London that aims to promote the creation and enjoyment of visual art through exhibitions, education and debate.

Salon
Originally, the official art exhibitions sponsored by the French government, the word came to be used for any large exhibition put on by the Parisian art academies, who typically refused to exhibit avant-garde work. This forced artists to set up alternative, anti-academic salons where they could exhibit modern and radical art.

Slade
The Slade School of Fine Art was founded as part of University College London in 1871 and thereafter played a crucial role in the development of modern art in Britain. It was renowned for its progressive teaching methods, such as life drawing, outdoor sketching and its encouragement of individual expression.

Social realism
A style of realism that became prominent in the 1920s and 1930s which focused on ordinary, and often working-class, people, providing social commentary and highlighting issues such as inequality and living conditions.

Sottobosco
From the Italian for 'undergrowth', a sub-genre of still life painting that depicts the shadowy world of the forest floor or the edges of lakes in intricate detail. Foregrounding the relationship between art and science, it emerged in Italy in the 1650s and became popular throughout Europe.

Surrealism
Movement that emerged in the 1920s which sought to explore the unconscious mind and the imagination. It is characterised by dreamlike imagery and unusual juxtapositions, and often uses symbolism to convey a deeper meaning.

Young British Artists (YBAs)
Group of provocative British artists who came out of Goldsmiths College in the late 1980s and gained widespread attention with their Sensation exhibition at the Royal Academy in 1997. Their often controversial work embraced unconventional materials and challenged the very definition of art.

Vanitas
The Latin word for vanity, meaning emptiness or a worthless action, and applied to a particular type of still life painting in which objects such as skulls and rotting fruit symbolically refer to decay, transience and mortality. Popular in 16th and 17th century Dutch and Flemish art.

Contributors

Lucy Davies is the former visual arts editor of the Telegraph, and now a writer and curator based in London. She is the author of several books on painting and photography and a regular contributor to national newspapers and magazines. She's also written lots for Hoxton Mini Press.

Hoxton Mini Press is a small independent publisher from east London. Independent ... Yes! We believe in books. We believe in beautiful books. We believe in beautiful books that you collect and put on nice wooden shelves and keep for future generations. We also plant loads of trees.

About the series

In an age when everything can be researched online we believe that strong opinion is better than more information. The intention of these 'opinionated' books is not to tell you everything, it's to spark curiousity and maybe just lift your day a little.

Picture credits

All images © The artists

An Opinionated Guide to Women Painters
First edition, first printing

Published in 2024 by Hoxton Mini Press, London
Copyright © Hoxton Mini Press 2024. All rights reserved.

Text by Lucy Davies
Editing by Octavia Stocker and Gaynor Sermon
Series design Tom Etherington
Production design by Richard Mason
Proofreading by Florence Ward
Editorial support by Megan Baffoe

A CIP catalogue record for this book is available from the British Library.

ISBN: 978-1-914314-55-1

Printed and bound by Finidr, Czechia

Hoxton Mini Press is an environmentally conscious publisher, committed
to offsetting our carbon footprint. This book is 100 percent carbon
compensated, with offset purchased from Stand For Trees.

Every time you order from our website, we plant a tree:
www.hoxtonminipress.com

MIX
Paper from
responsible sources
FSC® C014138